Giorgione

Herbert Cook

PREFACE

Unlike most famous artists of the past, Giorgione has not yet found a modern biographer. The whole trend of recent criticism has, in his case, been to destroy not to fulfil. Yet signs are not wanting that the disintegrating process is at an end, and that we have reached the point where reconstruction may be attempted. The discovery of documents and the recovery of lost pictures in the last few years have increased the available material for a more comprehensive study of the artist, and the time has come when the divergent results arrived at by independent modern inquirers may be systematically arranged, and a reconciliation of apparently conflicting views attempted on a psychological basis.

Crowe and Cavalcaselle were the first to examine the subject critically. They separated—so far as was then possible (1871)—the real from the traditional Giorgione, and their account of his life and works must still rank as the nearest equivalent to a modern biography. Morelli, who followed in 1877, was in singular sympathy with his task, and has written of his favourite master enthusiastically, yet with consummate judgment. Among living authorities, Dr. Gronau, Herr Wickhoff, Signor Venturi, and Mr. Bernhard Berenson have contributed effectively to the elucidation of obscure or disputed points, and the latter writer has probably come nearer than anyone to recognise the scope of Giorgione's art, and grasp the man behind his work. The monograph by Signor Conti and the chapter in Pater's *Renaissance* may be read for their delicate appreciations of the "Giorgionesque"; other contributions on the subject will be found in the Bibliography.

It is absolutely necessary for those whose judgment depends upon a study of the actual pictures to be constantly registering and adjusting their impressions. I have personally seen and studied all the pictures I believe to be by Giorgione, with the exception of those at St. Petersburg; and many galleries and churches where they hang have been visited repeatedly, and at considerable intervals of time. If in the course of years my individual

impressions (where they deviate from hitherto recognised views) fail to stand the test of time, I shall be the first to admit their inadequacy. If, on the other hand, they prove sound, some of the mists which at present envelop the figure of Giorgione will have been dispersed.

H.C.
November 1900

NOTE TO THE SECOND EDITION

To this Edition an Appendix has been added, containing—(1) an article by the Author on the age of Titian, which was published in the *Nineteenth Century* of January 1902; (2) the translation of a reply by Dr. Georg Gronau, published in the *Repertorium für Kunstwissenschaft*; (3) a further reply by the Author, published in the same German periodical.

The writer wishes to acknowledge his indebtedness to the Editors of the *Nineteenth Century* and of the *Repertorium* for permission to reprint these articles.

A better photograph of the "Portrait of an Unknown Man" at Temple Newsam has now been taken (p. 87), and sundry footnotes have been added to bring the text up to date.

H. C.
ESHER, *January* 1904.

BIBLIOGRAPHY

ANONIMO. "Notizia d'opere di disegno." Ed. Frizzoni. Bologna, 1884. *Passim.*

Archivio Storico dell' Arte (now *L'Arte*), 1888, p. 47. (See also *sub* Venturi.)

Art Journal. 1895. p. 90. (Dr. Richter.)

BERENSON, B. "Venetian Painting at the New Gallery." 1895. (Privately printed.) "Venetian Painters of the Renaissance." Third edition, 1897. Putnam, London. *Gazette des Beaux Arts*, 1897, p. 279.

BURCKHARDT. "Cicerone." Sixth edition, 1893. (Dr. Bode.)

CONTI, A. "Giorgione, Studio." Florence, 1894.

CROWE AND CAVALCASELLE. "History of Painting in North Italy," vol. ii. London, 1871. "Life of Titian." Two vols.

FRY, ROGER. "Giovanni Bellini." London, 1899.

GRONAU, DR. G. *Gazette des Beaux Arts*, 1894, p. 332. *Repertorium für Kunstwissenschaft*, xviii. 4, p. 284. "Zorzon da Castelfranco. La sua origine, la sua morte, e tomba." Venice, 1894. "Tizian." Berlin, 1900.

LAFENESTRE, G. "La vie et l'oeuvre de Titien." Paris, 1886.

LOGAN, MARY. "Guide to the Italian Pictures at Hampton Court." London, 1894.

Magazine of Art, 1890, pp. 91 and 138. (Sir W. Armstrong.) 1893. April. (Mr. W.F. Dickes.)

MORELLI, GIOVANNI. "Italian Painters." Translated by C.J. Ffoulkes. London, 1892. Vols. i. and ii. *passim.*

MÜNTZ, E. "La fin de la Renaissance." Paris.

New Gallery Catalogue of Exhibition of Venetian Art, 1895.

PATER, W. "The Renaissance." Chapter on the School of Giorgione. London, 1893.

PHILLIPS, CLAUDE. *Gazette des Beaux Arts*, 1884, p. 286. *Magazine of Art*, July 1895. "The Picture Gallery of Charles I." (*Portfolio*, January 1896).

"The Earlier Work of Titian" (*Portfolio*, October 1897). *North American Review*, October 1899.

Repertorium für Kunstwissenschaft. Bd. xiv. p. 316. (Herr von Seidlitz.) Bd. xix. Hft. 6. (Dr. Harck.)

RIDOLFI, C. "Le Maraviglie dell' arte della pittura." Venice, 1648.

Royal Academy. Catalogues of the Exhibitions of Old Masters.

VASARI. "Le Vite." Ed. Sansoni. Florence, 1879. Translation edited by Blashfield and Hopkins, with Notes. London, 1897.

VENTURI, ADOLFO. *Archivio Storico dell' Arte*, vi. 409, 412. *L'Arte*, 1900, p. 24, etc. "La Galleria Crespi in Milano," 1900.

WICKHOFF, F. *Gazette des Beaux Arts*, 1893, p. 135. *Jahrbuch der Preussischen Kunstsammlungen*, 1895. Heft i.

ZANETTI, A. "Varie Pitture," etc., with engravings of some fragments from the Fondaco de' Tedeschi frescoes, 1760.

CHAPTER I

GIORGIONE'S LIFE

Apart from tradition, very few ascertained facts are known to us as to Giorgione's life. The date of his birth is conjectural, there being but Vasari's unsupported testimony that he died in his thirty-fourth year. Now we know from unimpeachable sources that his death happened in October-November 1510,[1] so that, assuming Vasari's statement to be correct, Giorgione will have been born in 1477.[2]

The question of his birthplace and origin has been in great dispute. Without going into the evidence at length, we may accept with some degree of certainty the results at which recent German research has arrived.[3] Dr. Gronau's conclusion is that Giorgione was the son (or grandson) of a certain Giovanni, called Giorgione of Castelfranco, who came originally from the village of Vedelago in the march of Treviso. This Giovanni was living at Castelfranco, of which he was a citizen, in 1460, and there, probably, Giorgione his son (or grandson) was born some seventeen years later.

The tradition that the artist was a natural son of one of the great Barbarella family, and that in consequence he was called Barbarelli, is now shown to be false. This cognomen is first found in 1648, in Ridolfi's book, to which, in 1697, the picturesque addition was made that his mother was a peasant girl of Vedelago.[4] None of the earlier writers or contemporary documents ever allude to such an origin, or speak of "Barbarelli," but always of "Zorzon de Castelfrancho," "Zorzi da Castelfranco," and the like.[5]

We may take it as certain that Giorgione spent the whole of his short life in Venice and the neighbourhood. Unlike Titian, whose busy career was marked by constant journeyings and ever fresh incidents, the young Castelfrancan passed a singularly calm and uneventful life. Untroubled, apparently, by the storm and stress of the political world about him, he devoted himself with a whole-hearted simplicity to the advancement of his

art. Like Leonardo, he early won fame for his skill in music, and Vasari tells us the gifted young lute-player was a welcome guest in distinguished circles. Although of humble origin, he must have possessed a singular charm of manner, and a comeliness of person calculated to find favour, particularly with the fair sex. He early found a quasi-royal friend and patroness in Caterina Cornaro, ex-Queen of Cyprus, whose portrait he painted, and whose recommendation, as I believe, secured for him important commissions in the like field. But we may leave Giorgione's art for fuller discussion in the following chapters, and only note here two outside events which were not without importance in the young artist's career.

The one was the visit paid by Leonardo to Venice in the year 1500. Vasari tells us "Giorgione had seen certain works from the hand of Leonardo, which were painted with extraordinary softness, and thrown into powerful relief, as is said, by extreme darkness of the shadows, a manner which pleased him so much that he ever after continued to imitate it, and in oil painting approached very closely to the excellence of his model."[6] This statement has been combated by Morelli, but although historical evidence is wanting that the two men ever actually met, there is nothing improbable in Vasari's account. Leonardo certainly came to Venice for a short time in 1500, and it would be perfectly natural to find the young Venetian, then in his twenty-fourth year, visiting the great Florentine, long a master of repute, and from him, or from "certain works of his," taking hints for his own practice.[7]

The second event of moment to which allusion may here be made was the great conflagration in the year 1504, when the Exchange of the German Merchants was burnt. This building, known as the Fondaco de' Tedeschi, occupying one of the finest sites on the Grand Canal, was rebuilt by order of the Signoria, and Giorgione received the commission to decorate the façade with frescoes. The work was completed by 1508, and became the most celebrated of all the artist's creations. The Fondaco still stands to-day, but, alas! a crimson stain high up on the wall is all that remains to us of these great frescoes, which were already in decay when Vasari visited Venice in 1541.

Other work of the kind—all long since perished—Giorgione undertook with success. The Soranzo Palace, the Palace of Andrea Loredano, the Casa Flangini, and elsewhere, were frescoed with various devices, or

ornamented with monochrome friezes.

We know nothing of Giorgione's home life; he does not appear to have married, or to have left descendants. Vasari speaks of "his many friends whom he delighted by his admirable performance in music," and his death caused "extreme grief to his many friends to whom he was endeared by his excellent qualities." He enjoyed prosperity and good health, and was called Giorgione "as well from the character of his person as for the exaltation of his mind."[8]

He died of plague in the early winter of 1510, and was probably buried with other victims on the island of Poveglia, off Venice, where the lazar-house was situated.[9] The tradition that his bones were removed in 1638 and buried at Castelfranco in the family vault of the Barbarelli is devoid of foundation, and was invented to round off the story of his supposed connection with the family.[10]

NOTES:

[1]
See Appendix, where the documents are quoted in full.

[2]
Vasari gives 1478 (1477 in his first edition) and 1511 as the years of his birth and death. Crowe and Cavalcaselle, and Dr. Bode prefer to say "before 1477," a supposition which would make his precocity less phenomenal, and help to explain some chronological difficulties (see p. 66).

[3]
Zorzon da Castelfranco. La sua origine, la sua morte e tomba, by Dr. Georg Gronau. Venice, 1894.

[4]
Vide *Repertorium für Kunstwissenschaft*, xix. 2, p. 166. [Dr. Gronau.]

[5]
It would seem, therefore, desirable to efface the name of Barbarelli from the catalogues. The National Gallery, for example, registers Giorgione's work under this name.

[6]
The translation given is that of Blashfield and Hopkins's edition. Bell, 1897.

[7]

M. Müntz adduces strong arguments in favour of this view (*La fin de la Renaissance*, p. 600).

[8]

The name "Giorgione" signifies "Big George." But it seems to have been also his father's name.

[9]

This visitation claimed no less than 20,000 victims.

[10]

See Gronau, *op. cit.* Tradition has been exceptionally busy over Giorgione's affairs. The story goes that he died of grief at being betrayed by his friend and pupil, Morto da Feltre, who had robbed him of his mistress. This is now proved false by the document quoted in the Appendix.

CHAPTER II

GENERALLY ACCEPTED WORKS

Such, then, very briefly, are the facts of Giorgione's life recorded by the older biographers, or known by contemporary documents. Now let us turn to his artistic remains, the *disjecta membra*, out of which we may reconstruct something of the man himself; for, to those who can interpret it aright, a man's work is his best autobiography.

This is especially true in the case of an artist of Giorgione's temperament, for his expression is so peculiarly personal, so highly charged with individuality, that every product of mental activity becomes a revelation of the man himself. People like Giorgione must express themselves in certain ways, and these ways are therefore characteristic. Some people regard a work of art as something external; a great artist, they say, can vary his productions at will, he can paint in any style he chooses. But the exact contrary is the truth. The greater the artist, the less he can divest himself of his own personality; his work may vary in degree of excellence, but not in kind. The real reason, therefore, why it is impossible for certain pictures to be by Giorgione is, not that they are not *good* enough for him, but that they are not *characteristic*. I insist on this point, because in the matter of genuineness the touchstone of authenticity is so often to be looked for in an answer to the question: Is this or that characteristic? The personal equation is the all-important factor to be recognised; it is the connecting link which often unites apparently diverse phenomena, and explains what would otherwise appear to be irreconcilable.

There is an intimate relation then between the artist and his work, and, rightly interpreted, the latter can tell us much about the former.

Let us turn to Giorgione's work. Here we are brought face to face with an initial difficulty, the great difficulty, in fact, which has stood so much in the way of a more comprehensive understanding of the master, I mean,

that scarcely anything of his work is authenticated. Three pictures alone have never been called in question by contending critics; outside this inner ring is more or less debatable ground, and on this wider arena the battle has raged until scarcely a shred of the painter's work has emerged unscathed. The result has been to reduce the figure of Giorgione to a shadowy myth, whose very existence, at the present rate at which negative criticism progresses, will assuredly be called in question.

If Bacon wrote Shakespeare, then Giorgione can be divided up between a dozen Venetian artists, who "painted Giorgione." Fortunately three pictures survive which refuse to be fitted in anywhere else except under "Giorgione." This is the irreducible minimum, ο αναγκαιοτατος Giorgione, with which we must start.

Of the three universally accepted pictures, first and foremost comes the Castelfranco altar-piece, according to Mr. Ruskin "one of the two most perfect pictures in existence; alone in the world as an imaginative representation of Christianity, with a monk and a soldier on either side ... "[11] This great picture was painted before 1504, when the artist was only twenty-seven years of age,[12] a fact which clearly proves that his genius must have developed early. For not even a Giorgione can produce such a masterpiece without a long antecedent course of training and accomplishment. This is not the place to inquire into the nature and character of the works which lead up to this altar-piece, for a chronological survey ought to follow, not precede, an examination of all available material; it is important, nevertheless, to bear in mind that quite ten years had been passed in active work ere Giorgione produced this masterpiece.

If no other evidence were forthcoming as to the sort of man the painter was, this one production of his would for ever stamp him as a person of exquisite feeling. There is a reserve, almost a reticence, in the way the subject is presented, which indicates a refined mind. An atmosphere of serenity pervades the scene, which conveys a sense of personal tranquillity and calm. The figures are absorbed in their own thoughts; they stand isolated apart, as though the painter wishes to intensify the mood of dreamy abstraction. Nothing disquieting disturbs the scene, which is one of profound reverie. All this points to Giorgione being a man of moods, as we say; a lyric poet, whose expression is highly charged with personal feeling, who appeals

to the imagination rather than to the intellect. And so, as we might expect, landscape plays an important part in the composition; it heightens the pictorial effect, not merely by providing a picturesque background, but by enhancing the mood of serenity and solemn calm. Giorgione uses it as an instrument of expression, blending nature and human nature into happy unison. The effect of the early morning sun rising over the distant sea is of indescribable charm, and invests the scene with a poetic glamour which, as Morelli truly remarks, awakens devotional feelings. What must have been the effect when it was first painted! for even five modern restorations, under which the original work has been buried, have not succeeded in destroying the hallowing charm. To enjoy similar effects we must turn to the central Italian painters, to Perugino and Raphael; certainly in Venetian art of pre-Giorgionesque times the like cannot be found, and herein Giorgione is an innovator. Bellini, indeed, before him had studied nature and introduced landscape backgrounds into his pictures, but more for picturesqueness of setting than as an integral part of the whole; they are far less suggestive of the mood appropriate to the moment, less calculated to stir the imagination than to please the eye. Nowhere, in short, in Venetian art up to this date is a lyrical treatment of the conventional altar-piece so fully realised as in the Castelfranco Madonna.

Technically, Giorgione proclaims himself no less an innovator. The composition is on the lines of a perfect equilateral triangle, a scheme which Bellini and the older Venetian artists never adopted.[13] So simple a scheme required naturally large and spacious treatment; flat surfaces would be in place, and the draperies cast in ample folds. Dignity of bearing, and majestic sweep of dress are appropriately introduced; the colour is rich and harmonious, the preponderance of various shades of green having a soothing effect on the eye. The golden glow which doubtless once suffused the whole, has, alas! disappeared under cruel restorations, and flatness of tone has inevitably resulted, but we may still admire the play of light on horizontal surfaces, and the chiaroscuro giving solidity and relief to the figures.

An interesting link with Bellini is seen in the S. Francis, for the figure is borrowed from that master's altar-piece of S. Giobbe (now in the Venice Academy). Bellini's S. Francis had been painted seventeen or eighteen years before, and now we find Giorgione having recourse to the older master for a

pictorial motive. But, as though to assert his independence, he has created in the S. Liberale a type of youthful beauty and manliness which in turn became the prototype of subsequent knightly figures. Palma Vecchio, Mareschalco and Pennacchi all borrowed it for their own use, a proof that Giorgione's altar-piece acquired an early celebrity.[14]

Exquisite feeling is equally conspicuous in the other two works universally ascribed to Giorgione. These are the "Adrastus and Hypsipyle," in the collection of Prince Giovanelli, in Venice, and the "Aeneas, Evander, and Pallas," in the gallery at Vienna.[15]

ADRASTUS AND HYPSIPYLE

"The Giovanelli Figures," or "The Stormy Landscape, with the Soldier and the Gipsy," as the picture has been commonly called since the days of the Anonimo, who so described it in 1530, is totally unlike anything that Venetian art of the pre-Giorgionesque era has to show. The painted myth is a new departure, the creation of Giorgione's own brain, and as such, is treated in a wholly unconventional manner. His peculiarly poetical nature here finds full scope for display, his delicacy, his refinement, his sensitiveness to the beauties of the outside world, find fitting channels through which to express themselves. With what a spirit of romance Giorgione has invested his picture! So exquisitely personal is the mood, that the subject itself has taken his biographers nearly four centuries to decipher! For the artist, it must be noted, does not attempt to illustrate a passage of an ancient writer; very probably, nay, almost certainly, he had never read the *Thebaid* of Statius, whence comes the story of Adrastus and Hypsipyle; the subject would have been suggested to him by some friend, a student of the Classics, and Giorgione thereupon dressed the old Greek myth in Venetian garb, just as Statius had done in the Latin.[16] The story is known to us only at second hand, and we are at liberty to choose Giorgione's version in preference to that of the Roman poet; each is an independent translation of a common original, and certainly Giorgione's is not the less poetical. He has created a painted lyric which is not an illustration of, but a parallel presentation to the written poem of Statius.

Technically, the workmanship points to an earlier period than the Castelfranco Madonna, and there is an exuberance of fancy which points to a youthful origin. The figures are of slight and graceful build, the composition

easy and unstudied, with a tendency to adopt a triangular arrangement in the grouping, the apex being formed by the storm scene, to which the eye thus naturally reverts. The figures and the landscape are brought into close relation by this subtle scheme, and the picture becomes, not figures with landscape background, but landscape with figures.

The reproduction unduly exaggerates the contrasts of light and shade, and conveys little of the mellowness and richness of atmospheric effect which characterise the original. Unlike the brilliance of colouring in the Castelfranco picture, dark reds, browns, and greens here give a sombre tone which is accentuated by the dullness of surface due to old varnishes.

AENEAS, EVANDER, AND PALLAS

"The Three Philosophers," or "The Chaldean Sages," as the picture at Vienna has long been strangely named, shows the artist again treating a classical story in his own fantastic way. Virgil has enshrined in verse the legend of the arrival of the Trojan Aeneas in Italy,[17] and Giorgione depicts the moment when Evander, the aged seer-king, and his son Pallas point out to the wanderer the site of the future Capitol. Again we find the same poetical presentation, not representation, of a legendary subject, again the same feeling for the beauties of nature. How Giorgione has revelled in the glories of the setting sun, the long shadows of the evening twilight, the tall-stemmed trees, the moss-grown rock! The figures are but a pretext, we feel, for an idyllic scene, where the story is subordinated to the expression of sensuous charm.

This work was seen by the Anonimo in 1525, in the house of Taddeo Contarini at Venice. It was then believed to have been completed by Sebastiano del Piombo, Giorgione's pupil. If so,—and there is no valid reason to doubt the statement,—Giorgione left unfinished a picture on which he was at work some years before his death, for the style clearly indicates that the artist had not yet reached the maturity of his later period. The figures still recall those of Bellini, the modelling is close and careful, the forms compact, and reminiscent of the quattrocento. It is noticeable that the type of the Pallas is identical with that of S. John Baptist in Sebastiano's early altar-piece in S. Giovanni Crisostomo at Venice, but it would be unwise to dramatise on the share (if any) which the pupil had in completing the work of his master.

The credit of invention must indubitably rest with Giorgione, but the damage which the picture has sustained through neglect and repainting in years gone by, renders certainty of discrimination between the two hands a matter of impossibility.

The colouring is rich and varied; the orange horizon, the distant blue hill, and the pale, clear evening light, with violet-tinted clouds, give a wonderful depth behind the dark tree-trunks. The effect of the delicate leaves and feathery trees at the edge of the rock, relieved against the pale sky, is superb. A spirit of solemnity broods over the scene, fit feeling at so eventful a moment in the history of the past.

The composition, which looks so unstudied, is really arranged on the usual triangular basis. The group of figures on the right is balanced on the left by the great rock—the future Capitol—(which is thus brought prominently into notice), and the landscape background again forms the apex. The added depth and feeling for space shows how Giorgione had learnt to compose in three dimensions, the technical advance over the "Adrastus and Hypsipyle" indicating a period subsequent to that picture, though probably anterior to the Castelfranco altar-piece.

We have now taken the three universally accepted Giorgiones; how are we to proceed in our investigations? The simplest course will be to take the pictures acknowledged by those modern writers who have devoted most study to the question, and examine them in the light of the results to which we have attained. Those writers are Crowe and Cavalcaselle, who published their account of Giorgione in 1871, and Morelli, who wrote in 1877. Now it is notorious that the results at which these critics arrived are often widely divergent, but a great deal too much has been made of the differences and not enough of the points of agreement.

THE JUDGMENT OF SOLOMON

As a matter of fact, Morelli only questions three of the thirteen Giorgiones accepted definitely by Crowe and Cavalcaselle. Leaving these three aside for the moment, we may take the remaining ten (three of which we have already examined), and after deducting three others in English collections to which Morelli does not specifically refer, we are left with four more pictures on which these rival authorities are agreed.

These are the two small works in the Uffizi, representing the

"Judgment of Solomon" and the "Trial of Moses," the "Knight of Malta," also in the Uffizi, and the "Christ bearing the Cross," till lately in the Casa Loschi at Vicenza, and now belonging to Mrs. Gardner of Boston, U.S.A.

The two small companion pictures in the Uffizi, The "Judgment of Solomon" and the "Trial of Moses," or "Ordeal by Fire," as it is also called, connect in style closely with the "Adrastus and Hypsipyle." They are conceived in the same romantic strain, and carried out with scarcely less brilliance and charm. The story, as in the previous pictures, is not insisted upon; the biblical episode and the rabbinical legend are treated in the same fantastic way as the classic myth. Giovanni Bellini had first introduced this lyric conception in his treatment of the mediaeval allegory, as we see it in his picture, also in the Uffizi, hanging near the Giorgiones; all three works were originally together in the Medici residence of Poggio Imperiale, and there can be little doubt are intimately related in origin to one another. Bellini's latest biographer, Mr. Roger Fry, places this Allegory about the years 1486-8, a date which points to a very early origin for the other two.[18] For it is extremely likely that the young Giorgione was inspired by his master's example, and that he may have produced his companion pieces as early as 1493. With this deduction Morelli is in accord: "In character they belong to the fifteenth century, and may have been painted by Giorgione in his sixteenth or eighteenth year."[19]

THE TRIAL OF MOSES

Here, then, is a clue to the young artist's earliest predilections. He fastens eagerly upon that phase of Bellini's art to which his own poetic temperament most readily responds. But he goes a step further than his master. He takes his subjects not from mediaeval romances, but from the Bible or rabbinical writings, and actually interprets them also in this new and unorthodox way. So bold a departure from traditional usage proves the independence and originality of the young painter. These two little pictures thus become historically the first-fruits of the neo-pagan spirit which was gradually supplanting the older ecclesiastical thought, and Giorgione, once having cast conventionalism aside, readily turns to classical mythology to find subjects for the free play of fancy. The "Adrastus and Hypsipyle" thus

follows naturally upon "The Judgment of Solomon" and "Trial of Moses," and the pages of Virgil, Ovid, Statius, and Valerius Flaccus—all treasure-houses of golden legend—yield subjects suggestive of romance. The titles of some of these *poesie*, as they were called, are preserved in the pages of Ridolfi.[20]

[Illustration: *Alinari photo. Uffizi Gallery, Florence*
THE TRIAL OF MOSES]

The tall and slender figures, the attitudes, and the general *mise-en-scène* vividly recall the earlier style of Carpaccio, who was at this very time composing his delightful fairy tales of the "Legend of S. Ursula."[21] Common to both painters is a gaiety and love of beauty and colour. There is also in both a freedom and ease, even a homeliness of conception, which distinguishes their work from the pageant pictures of Gentile Bellini, whose "Corpus Christi Procession" was produced two or three years later, in 1496.[21] But Giorgione's art is instinct with a lyrical fancy all his own, the story is subordinated to the mood of the moment, and he is much more concerned with the beauty of the scene than with its dramatic import.

The repainted condition of "The Judgment of Solomon" has led some good judges to pronounce it a copy. It certainly lacks the delicacy that distinguishes its companion piece, but may we not—with Crowe and Cavalcaselle and Morelli—register it rather as a much defaced original?

CHRIST BEARING THE CROSS

So far as we have at present examined Giorgione's pictures, the trend of thought they display has been mostly in the direction of secular subjects. The two early examples just described show that even where the subject is quasi-religious, the revolutionary spirit made itself felt; but it would be perfectly natural to find the young artist also following his master Giambellini in the painting of strictly sacred subjects. No better example could be found than the "Christ bearing the Cross," the small work which has recently left Italy for America. We are told by the Anonimo that there was in his day (1525) a picture by Bellini of this subject, and it is remarkable that four

separate versions exist to-day which, without being copies of one another, are so closely related that the existence of a common original is a legitimate inference. That this was by Bellini is more than probable, for the different versions are clearly by different painters of his school. By far the finest is the example which Crowe and Cavalcaselle and Morelli unhesitatingly ascribe to the young Giorgione; this version is, however, considered by Signor Venturi inferior to the one now belonging to Count Lanskeronski in Vienna.[22] Others who, like the writer, have seen both works, agree with the older view, and regard the latter version, like the others at Berlin and Rovigo, as a contemporary repetition of Bellini's lost original.[23]

Characteristic of Giorgione is the abstract thought, the dreaminess of look, the almost furtive glance. The minuteness of finish reminds us of Antonello, and the turn of the head suggests several of the latter's portraits. The delicacy with which the features are modelled, the high forehead, and the lighting of the face are points to be noted, as we shall find the same characteristics elsewhere.

THE KNIGHT OF MALTA

The "Knight of Malta," in the Uffizi, is a more mature work, and reveals Giorgione to us as a portrait painter of remarkable power. The conception is dignified, the expression resolute, yet tempered by that look of abstract thought which the painter reads into the faces of his sitters. The hair parted in the middle, and brought down low at the sides of the forehead, was peculiarly affected by the Venetian gentlemen of the day, and this style seems to have particularly pleased Giorgione, who introduces it in many other pictures besides portraits. The oval of the face, which is strongly lighted, is also characteristic. This work shows no direct connection with Bellini's portraiture, but far more with that which we are accustomed to associate with the names of Titian and Palma. It dates probably from the early part of the sixteenth century, at a time when Giorgione was breaking with the older tradition which had strictly limited portraiture to the representation of the head only, or at most to the bust. The hand is here introduced, though Giorgione feels still compelled to account for its presence by introducing a rosary of large beads. In later years, as we shall see, the expressiveness of the human hand *per se* will be recognised; but Giorgione already feels its

significance in portraiture, and there is not one of his portraits which does not show this.[24]

The list of Giorgione's works now numbers seven; the next three to be discussed are those that Crowe and Cavalcaselle added on their own account, but about which Morelli expressed no opinion. Two are in English private collections, the third in the National Gallery. This is the small "Knight in Armour," said to be a study for the figure of S. Liberale in the Castelfranco altar-piece. The main difference is that in the latter the warrior wears his helmet, whilst in the National Gallery example he is bareheaded. By some this little figure is believed to be a copy, or repetition with variations, of Giorgione's original, but it must honestly be confessed that absolutely no proof is forthcoming in support of this view. The quality of this fragment is unquestionable, and its very divergence from the Castelfranco figure is in its favour. It would perhaps be unsafe to dogmatise in a case where the material is so slight, but until its genuineness can be disproved by indisputable evidence, the claim to authenticity put forward in the National Gallery catalogue, following Crowe and Cavalcaselle's view, must be allowed.

The two remaining pictures definitely placed by Crowe and Cavalcaselle among the authentic productions of Giorgione are the "Adoration of the Shepherds," belonging to Mr. Wentworth Beaumont, and the "Judgment of Solomon," in the possession of Mr. Ralph Bankes at Kingston Lacy, Dorsetshire.

THE ADORATION OF THE SHEPHERDS

The former (of which an inferior replica with differences of landscape exists in the Vienna Gallery) is one of the most poetically conceived representations of this familiar subject which exists. The actual group of figures forms but an episode in a landscape of the most entrancing beauty, lighted by the rising sun, and wrapped in a soft atmospheric haze. The landscapes in the two little Uffizi pictures are immediately suggested, yet the quality of painting is here far superior, and is much closer in its rendering of atmospheric effects to the "Adrastus and Hypsipyle." The figures, on the other hand, are weak, very unequal in size, and feebly expressed, except the Madonna, who has charm. The lights and shadows are treated in a masterly way, and contrasts of gloom and sunlight enhance the solemnity of the scene. The general tone is rich and full of subdued colour.

Now if the name of Giorgione be denied this "Nativity," to which of the followers of Bellini are we to assign it?—for the work is clearly of Bellinesque stamp. The name of Catena has been proposed, but is now no longer seriously supported.[25] If for no other reason, the colour scheme is sufficient to exclude this able artist, and, versatile as he undoubtedly was, it may be questioned whether he ever could have attained to the mellowness and glow which suffuse this picture. The latest view enunciated[26] is that "we are in the presence of a painter as yet anonymous, whom in German fashion we might provisionally name 'The Master of the Beaumont "Adoration."'" Now this system of labelling certain groups of paintings showing common characteristics is all very well in cases where the art history of a particular school or period is wrapt in obscurity, and where few, if any, names have come down to us, but in the present instance it is singularly inappropriate. To begin with, this anonymous painter is the author, so it is believed, of only three works, this "Adoration," the "Epiphany," in the National Gallery, No. 1160, and a small "Holy Family," belonging to Mr. Robert Benson in London, for all three works are universally admitted to be by the same hand. Next, this anonymous painter must have been a singularly refined and poetical artist, a master of brilliant colour, and an accomplished chiaroscurist. Truly a *deus ex machina*! Next you have to find a vacancy for such a phenomenon in the already crowded lists of Bellini's pupils and followers, as if there were not more names than enough already to fully account for every Bellinesque production.[27] No, this is no question of compromise, of the dragging to light some hitherto unknown genius whose identity has long been merged in that of bigger men, but it is the recognition of the fact that the greater comprises the less. Admitting, as we may, that these three pictures are inferior in "depth, significance, cohesion, and poetry" (!) to the Castelfranco "Madonna," there is nothing to show that they are not characteristic of Giorgione, that they do not form part of a consistent whole. As a matter of fact, this "Adoration of the Shepherds" connects very well with the early *poésie* already discussed. There is some opposition between the sacred theme and Giorgione's natural dislike to tell a mere story; but he has had to conform to traditional methods of representation, and the feeling of restraint is felt in the awkward drawing of the figures, and their uneven execution. That he felt dissatisfied with this portion of the work, the drawing at Windsor plainly

shows, for the figures appear here in a different position, as if he had tried to recast his scheme.

Some may object that the drawing of the shepherd is atrocious, and that the figures are of disproportionate sizes. Such failings, they say, cannot be laid to a great master's charge. This is an appeal to the old argument that it is not *good* enough, whereas the true test lies in the question, Is it *characteristic?* Of Giorgione it certainly is a characteristic to treat each figure in a composition more or less by itself; he isolates them, and this conception is often emphasised by an outward disparity of size. The relative disproportion of the figures in the Castelfranco altar-piece, and of those of Aeneas and Evander in the Vienna picture can hardly be denied, yet no one has ever pleaded this as a bar to their authenticity. Instances of this want of cohesion, both in conception and execution, between the various figures in a scene could be multiplied in Giorgione's work, no more striking instance being found than in the great undertaking he left unfinished—the large "Judgment of Solomon," next to be discussed. Moreover, eccentricities of drawing are not uncommon in his work, as a reference to the "Adrastus and Hypsipyle," and later works, like the "Fête Champêtre" (of the Louvre), will show.

I have no hesitation, therefore, in recognising this "Adoration of the Shepherds" as a genuine work of Giorgione, and, moreover, it appears to be the masterpiece of that early period when Bellini's influence was still strong upon him.

The Vienna replica, I believe, was also executed by Giorgione himself. Until recent times, when an all too rigorous criticism condemned it to be merely a piece of the "Venezianische Schule um 1500" (which is correct as far as it goes),[28] it bore Giorgione's name, and is so recorded in an inventory of the year 1659. It differs from the Beaumont version chiefly in its colouring, which is silvery and of delicate tones. It lacks the rich glow, and has little of that mysterious glamour which is so subtly attractive in the former. The landscape is also different. We must be on our guard, therefore, against the view that it is merely a copy; differences of detail, especially in the landscape, show that it is a parallel work, or a replica. Now I believe that these two versions of the "Nativity" are the two pictures of "La Notte," by Giorgione, to which we have allusion in a contemporary document.[29] The description, "Una Notte," obviously means what we term "A Nativity"

(Correggio's "Heilige Nacht" at Dresden is a familiar instance of the same usage), and the difference in quality between the two versions is significantly mentioned. It seems that Isabella d'Este, the celebrated Marchioness of Mantua, had commissioned one of her agents in Venice to procure for her gallery a picture by Giorgione. The agent writes to his royal mistress and tells her (October 1510) that the artist is just dead, and that no such picture as she describes—viz. "Una Nocte"—is to be found among his effects. However, he goes on, Giorgione did paint two such pictures, but these were not for sale, as they belonged to two private owners who would not part with them. One of these pictures was of better design and more highly finished than the other, the latter being, in his opinion, not perfect enough for the royal collection. He regrets accordingly that he is unable to obtain the picture which the Marchioness requires.

If my conjecture be right, we have in the Beaumont and Vienna "Nativities" the only two pictures of Giorgione to which allusion is made in an absolutely contemporary document, and they thus become authenticated material with which to start a study of the master.

The next picture, which Crowe and Cavalcaselle accept without question, is the large "Judgment of Solomon," belonging to Mr. Bankes at Kingston Lacy. The scene is a remarkable one, conceived in an absolutely unique way; Solomon is here posed as a Roman Praetor giving judgment in the Atrium, supported on each side by onlookers attired in fanciful costume of the Venetian period, or suggestive of classical models. It is the strangest possible medley of the Bellinesque and the antique, knit together by harmonious colouring and a clever grouping of figures in a triangular design. As an interpretation of a dramatic scene it is singularly ineffective, partly because it is unfinished, some of the elements of the tragedy being entirely wanting, partly because of an obvious stageyness in the action of the figures taking part in the scene. There is a want of dramatic unity in the whole; the figures are introduced in an accidental way, and their relative proportion is not accurately preserved; the executioner, for example, is head and shoulders larger than anyone else, whilst the two figures standing on the steps of Solomon's throne are in marked contrast. The one with the shield, on the left, is as monumental as one of Bramante's creations, the old gentleman with the beard, on the right, is mincing and has no shoulders. Solomon himself

appears as a young man of dark complexion, in an attitude of self-contained determination; the way his hands rest on the sides of the throne is very expressive. His drapery is cast in curious folds of a zig-zag character, following the lines of the composition, whilst the dresses of the other personages fall in broad masses to the ground. The light and shade are cleverly handled, and the spaciousness of the scene is enhanced by the rows of columns and the apse of mosaics behind Solomon's head. The painter was clearly versed in the laws of perspective, and indicates depth inwards by placing the figures behind one another on a tesselated pavement or on the receding steps of the throne, giving at the same time a sense of atmospheric space between one figure and another. The colour scheme is delightful, full-toned orange and red alternating with pale blues, olive green, and delicate pink, the contrasts so subdued by a clever balance of light and shade as to harmonise the whole in a delicate silvery key.

THE JUDGMENT OF SOLOMON (Unfinished)

The unfinished figure of the executioner evidently caused the artist much trouble, for *pentimenti* are frequent, and other outlines can be distinctly traced through the nude body. The effect of this clumsy figure is far from satisfactory; the limbs are not articulated distinctly; moreover, the balance of the whole composition is seriously threatened by the tragedy being enacted at the side instead of in the middle. The artist appears to have felt this difficulty so much that he stopped short at this point; at any rate, the living child remains unrepresented, nor is there any second child such as is required to illustrate the story. It looks as though the scheme was not carefully worked out before commencing, and that the artist found himself in difficulties at the last, when he had to introduce the dramatic motive, which apparently was not to his taste.

Now, all this fits in exactly with what we know of Giorgione's temperament; lyrical by nature, he would shrink from handling a great dramatic scene, and if such a task were imposed upon him he would naturally treat three-fourths of the subject in his own fantastic way, and do his best to illustrate the action required in the remaining part. The result would be (what might be expected) forced or stagey, and the action rhetorical, and that is exactly what has happened in this "Judgment of Solomon."

It is a natural inference that, supposing Giorgione to be the painter, he would never have selected such a subject of his own free will to be treated, as this is, on so large a scale. There may be, therefore, something in the suggestion which Crowe and Cavalcaselle make that this may be the large canvas ordered of Giorgione for the audience chamber of the Council, "for which purpose," they add, "the advances made to him in the summer of 1507 and in January 1508 show that the work he had undertaken was of the highest consequence."[30]

Be this as it may, the picture was in Venice, in the Casa Grimani di Santo Ermagora,[31] in Ridolfi's day (1646), and that writer specially mentions the unfinished executioner. It passed later into the Marescalchi Gallery at Bologna, where it was seen by Lord Byron (1820), and purchased at his suggestion by his friend Mr. Bankes, in whose family it still remains.[32]

It will be gathered from what I have written that Giorgione and no other is, in my opinion, the author of this remarkable work. Certain of the figures are reminiscent of those by him elsewhere—e.g. the old man with the beard is like the Evander in the Vienna picture, the young man next the executioner resembles the Adrastus in the Giovanelli figures, and the young man stooping forward next to Solomon recurs in the "Three Ages," in the Pitti, which Morelli considered to be by Giorgione. The most obvious resemblances, however, are to be found in the Glasgow "Adulteress before Christ," a work which several modern critics assign to Cariani, although Dr. Bode, Sir Walter Armstrong, and others, maintain it to be a real Giorgione. Consistently enough, those who believe in Cariani's authorship in the one case, assert it in the other,[33] and as consistently I hold that both are by Giorgione. It is conceivable that Cariani may have copied Giorgione's types and attitudes, but it is inconceivable to me that he can have so entirely assimilated Giorgione's temperament to which this "Judgment of Solomon" so eloquently witnesses. Moreover, let no one say that Cariani executed what Giorgione designed, for, in spite of its imperfect condition, the technique reveals a painter groping his way as he works, altering contours, and making corrections with his brush; in fact, it has all the spontaneity which characterises an original creation.

The date of its execution may well have been 1507-8, perhaps even earlier; at any rate, we must not argue from its unfinished state that the

painter's death prevented completion, for the style is not that of Giorgione's last works. Rather must we conclude that, like the "Aeneas and Evander," and several other pictures yet to be mentioned, Giorgione stopped short at his work, unwilling to labour at an uncongenial task (as, perhaps, in the present case), or from some feeling of dissatisfaction at the result, nay, even despair of ever realising his poetical conceptions.

To this important trait in Giorgione's character further reference will be made when all the available material has been examined; suffice it for the moment that this "Judgment of Solomon" is to me a most *typical* example of the great artist's work, a revelation alike of his weaknesses as of his powers.

Following our method of investigation we will next consider the pictures which Morelli accredits to Giorgione over and above the seven already discussed, wherein he concurs with Crowe and Cavalcaselle. These are twelve in number, and include some of the master's finest works, some of them unknown to the older authorities, or, at any rate, unrecorded by them. Here, therefore, the opinions of Crowe and Cavalcaselle are not of so much weight, so it will be necessary to see how far Morelli's views have been confirmed by later writers during the last twenty years.

Three portraits figure in Morelli's list—one at Berlin, one at Buda-Pesth, and one in the Borghese Gallery at Rome.

PORTRAIT OF A YOUNG MAN

First, as to the Berlin "Portrait of a Young Man," which, when Morelli wrote, belonged to Dr. Richter, and was afterwards acquired for the Berlin Gallery. "In it we have one of those rare portraits such as only Giorgione, and occasionally Titian, were capable of producing, highly suggestive, and exercising over the spectator an irresistible fascination."[34] Such are the great critic's enthusiastic words, and no one surely to-day would be found to gainsay them. We may note the characteristic treatment of the hair, the thoughtful look in the eyes, and the strong light on the face in contrast to the dark frame of hair, points which this portrait shares in common with the "Knight of Malta" in the Uffizi. Particularly to be noticed, however, is the parapet on which the fingers of one hand are visible, and the mysterious letters VV.[35] Allusion has already been made to the growing

practice in Venetian art of introducing the hand as a significant feature in portrait painting, and here we get the earliest indications of this tendency in Giorgione; for this portrait certainly ante-dates the "Knight of Malta." It would seem to have been painted quite early in the last decade of the fifteenth century, when Bellini's art would still be the predominant influence over the young artist.

PORTRAIT OF A MAN

It is but a step onward to the next portrait, that of a young man, in the Gallery at Buda-Pesth, but the supreme distinction which marks this wonderful head stamps it as a masterpiece of portraiture. Venetian art has nothing finer to show, whether for its interpretative qualities, or for the subtlety of its execution. Truly Giorgione has here foreshadowed Velasquez, whose silveriness of tone is curiously anticipated; yet the true Giorgionesque quality of magic is felt in a way that the impersonal Spaniard never realised. Only those who have seen the original can know of the wonderful atmospheric background, with sky, clouds, and hill-tops just visible. The reproduction, alas! gives no hint of all this. Nor can one appreciate the superb painting of the black quilted dress, with its gold braid, or of the shining black hair, confined in a brown net. The artist must have been in keen sympathy with this melancholy figure, for the expression is so intense that, as Morelli says, "he seems about to confide to us the secret of his life."[36]

Several points claim our attention. First, the parapet has an almost illegible inscription, ANTONIVS. BROKARDVS. M[=ARI]I.F, presumably the young man's name. Further, we may notice the recurrence of the letter V on a black device, and there is a second curious black tablet, which, however, has nothing on it. Between the two is a circle with a device of three heads in one surrounded by a garland of flowers. No satisfactory explanation of these symbols can be offered, but if the second black tablet had originally another V, we might conclude that these letters were in some mysterious way connected with Giorgione, as they appear also on the Berlin portrait. I shall be able to show that another instance of this double V exists on yet another portrait by Giorgione.[37]

Finally, the expressiveness of the human hand is here fully realised. This feature alone points to a later date than the "Knight of Malta," and considerably after the still earlier Berlin portrait. The consummate mastery of technique, moreover, indicates that Giorgione has here reached full maturity, so that it would be safe to place this portrait about the year 1508.

Signor Venturi ("La Galleria Crespi") ascribes this portrait to Licinio. This is one of those inexplicable perversions of judgment to which even the best critics are at times liable. In *L'Arte*, 1900, p. 24, the same writer mentions that a certain Antonio Broccardo, son of Marino, made his will in 1527, and that the same name occurs among those who frequented the University of Bologna in 1525. There is nothing to prevent Giorgione having painted this man's portrait when younger.

PORTRAIT OF A LADY

The third portrait in Morelli's list has not had the same friendly reception at the hands of later critics as the preceding two have had. This is the "Portrait of a Lady" in the Borghese Gallery at Rome, whose discovery by Morelli is so graphically described in a well-known passage.[38] And in truth it must be confessed that the authorship of this portrait is not at first sight quite so evident as in the other cases; nevertheless I am firmly convinced that Morelli saw further than his critics, and that his intuitive judgment was in this instance perfectly correct.[39] The simplicity of conception, the intensity of expression, the pose of the figure alike proclaim the master, whose characteristic touch is to be seen in the stone ledge, the fancy head-dress, the arrangement of hair, and the modelling of the features. The presence of the hands is characteristically explained by the handkerchief stretched tight between them, the action being expressive of suppressed excitement: "She stands at a window ... gazing out with a dreamy, yearning expression, as if seeking to descry one whom she awaits."

Licinio, whose name has been proposed as the painter, did indeed follow out this particular vein of Giorgione's portraiture, so that "Style of Licinio" is not an altogether inapt attribution; but there is just that difference of quality between the one man's work and the other, which distinguishes any great man from his followers, whether in literature or in art. How near (and

yet how far!) Licinio came to his great prototype is best seen in Lady Ashburton's "Portrait of a Young Man,"[40] but that he could have produced the Borghese "Lady" presupposes qualities he never possessed. "To Giorgione alone was it given to produce portraits of such astonishing simplicity, yet so deeply significant, and capable, by their mystic charm, of appealing to our imagination in the highest degree."[41]

The actual condition of this portrait is highly unsatisfactory, and is adduced by some as a reason for condemning it. Yet the spirit of the master seems still to breathe through the ruin, and to justify Morelli's ascription, if not the enthusiastic language in which he writes.

APOLLO AND DAPHNE

With the fourth addition on Morelli's list we pass into a totally different sphere of art—the decoration of *cassoni*, and other pieces of furniture. We have seen Giorgione at work on legendary stories or classic myths, creating out of these materials pages of beauty and romance in the form of easel paintings, and now we have the same thing as applied art—that is, art used for purely decorative purposes. The "Apollo and Daphne" in the Seminario at Venice was probably a panel of a *cassone*; but although intended for so humble a place, it is instinct with rare poetic feeling and beauty. Unfortunately it is in such a bad state that little remains of the original work, and Giorgione's touch is scarcely to be recognised in the damaged parts. Nevertheless, his spirit breathes amidst the ruin, and modern critics have recognised the justice of Morelli's view, rather than that of Crowe and Cavalcaselle, who suggested Schiavone as the "author."[42] And, indeed, a comparison with the "Adrastus and Hypsipyle" is enough to show a common origin, although, as we might expect, the same consummate skill is scarcely to be found in the *cassone* panel as in the easel picture. There is a rare daintiness, however, in these graceful figures, so essentially Giorgionesque in their fanciful presentation, the young Apollo, a lovely, fair-haired boy, pursuing a maiden with flowing tresses, whose identity with Daphne is only to be recognised by the laurel springing from her fingers. The story is but an episode in a sylvan scene, where other figures, in quaint costumes, seem to be leading an idyllic existence, untroubled by the cares of life, and utterly

unconcerned at the strange event passing before their eyes.

From the "Apollo and Daphne" it is an easy transition to the "Venus," that great discovery which we owe to Morelli, and now universally recognised by modern critics. The one point on which Morelli did not, perhaps, lay sufficient stress, is the co-operation in this work of Titian with Giorgione, for here we have an additional proof that the latter left some of his work unfinished. It is a fair inference that Titian completed the Cupid (now removed), and that he had a hand in finishing the landscape; the Anonimo, indeed, states as much, and Ridolfi confirms it, and this view is officially adopted in the latest edition of the Dresden Catalogue. The style points to Giorgione's maturity, though scarcely to the last years of his life; for, in spite of the freedom and breadth of treatment in the landscape, there is a restraint in the figure, and a delicacy of form which points to a period preceding, rather than contemporary with, the Louvre "Concert" and kindred works, where the forms become fuller and rounder, and the feeling more exuberant.

VENUS

It would be mere repetition, after all that has been written on the Dresden "Venus," to enlarge on the qualities of refinement and grace which characterise the fair form of the sleeping goddess. One need but compare it with Titian's representations of the same subject, and still more with Palma's versions at Dresden and Cambridge, or with Cariani's "Venus" at Hampton Court, to see the classic purity of form, the ideal loveliness of Giorgione's goddess.[43] It is no mere accident that she alone is sleeping, whilst they solicit attention. Giorgione's conception is characteristic in that he endeavours to avoid any touch of realism abhorrent to his nature, which was far more sensitive than that of Palma, Cariani, or even Titian.

The extraordinary beauty and subtlety of the master's "line" is admirably shown. He has deliberately forgone anatomical precision in order to accentuate artistic effect. The splendour of curve, the beauty of unbroken contour, the rhythm and balance of composition is attained at a cost of academic correctness; but the long-drawn horizontal lines heighten the sense of repose, and the eye is soothed by the sinuous undulations of landscape and

figure. The artistic effect is further enhanced by the relief of exquisite flesh tones against the rich crimson drapery, and although the atmospheric glow has been sadly destroyed by abrasion and repainting, we may still feel something of the magic charm which Giorgione knew so well how to impart.

This "Venus" is the prototype of all other Venetian versions; it is in painting what the "Aphrodite" of Praxiteles was in sculpture, a perfect creation of a master mind.

JUDITH

Scarcely less wonderful than the "Venus," and even surpassing it in solemn grandeur of conception, is the "Judith" at St. Petersburg. Morelli himself had never seen the original, and includes it in his list with the reservation that it might be an old copy after Giorgione, and not the original. It would be presumptuous for anyone not familiar with the picture to decide the point, but I have no hesitation in following the judgment of two competent modern critics, both of whom have recently visited St. Petersburg, and both of whom have decided unhesitatingly in favour of its being an original by Giorgione. Dr. Harck has written enthusiastically of its beauty. "Once seen," he says, "it can never be forgotten; the same mystic charm, so characteristic of the other great works of Giorgione, pervades it; ... it bears on the face of it the stamp of a great master."[44] Even more decisive is the verdict of Mr. Claude Phillips.[45] "All doubts," he says, "vanish like sun-drawn mist in the presence of the work itself; the first glance carries with it conviction, swift and permanent. In no extant Giorgione is the golden glow so well preserved, in none does the mysterious glamour from which the world has never shaken itself free, assert itself in more irresistible fashion.... The colouring is not so much Giorgionesque as Giorgione's own—a widely different thing.... Wonderful touches which the imitative Giorgionesque painter would not have thought of are the girdle, a mauve-purple now, with a sharply emphasised golden fringe, and the sapphire-blue jewel in the brooch. Triumphs of execution, too, but not in the broad style of Venetian art in its fullest expansion, are the gleaming sword held in so dainty and feminine a fashion, and the flowers which enamel the ground at the feet of the Jewish heroine." This "Judith," after passing for many years under the names of

Raphael and Moretto,[46] is now officially recognised as Giorgione's work, an identification first made by the late Herr Penther, the keeper of the Vienna Academy, whom Morelli quotes.

The conception is wholly Giorgionesque, the mood one of calm contemplation, as this lovely figure stands lost in reverie, with eyes cast down, gazing on the head on which her foot is lightly laid. The head and sword proclaim her story, they are symbols of her mission, else she had been taken for an embodiment of feminine modesty and gentle submissiveness.[47]

Characteristic of the master is the introduction of the great tree-trunk conveying a sense of grandeur and solemn mystery to the scene characteristic, too, is the distant landscape, the splendid glow of which evokes special praise from the writers just mentioned. Again we find the parapet, or ledge, with its flat surface on which the play of light can be caught, and again the same curious folds, broken and crumpled, such as are seen on Solomon's robe in the Kingston Lacy picture, and somewhat less emphatically in the Castelfranco "Madonna."

Consistent, moreover, with that weakness we have already noticed elsewhere, is the design of the leg and foot, the drawing of which is far from impeccable. That the execution in this respect is not equal to the supreme conception of the whole, is no valid reason for the belief that this "Judith" is only a copy of a lost original, a belief that could apparently only be held by those who have never stood before the picture itself.[48] But even in the reproduction this "Judith" stands confessed as the most impressive of all Giorgione's single figures, and it may well rank as the masterpiece of the earlier period immediately preceding the Castelfranco picture of about 1504, to which in style it closely approximates.

A PASTORAL SYMPHONY

The next picture on Morelli's list is the "Fête Champêtre" of the Louvre, or, as it is often called, the "Concert." This lovely "Pastoral Symphony" (which appears to me a more suitable English title) is by no means universally regarded as a creation of Giorgione's hand and brain, and several modern critics have been at pains to show that Campagnola, or some other Venetian imitator of the great master, really produced it.[49] In this

endeavour Crowe and Cavalcaselle led the way by suggesting the author was probably an imitator of Sebastiano del Piombo. But all this must surely seem to be heresy when we stand before the picture itself, thrilled by the gorgeousness of its colour, by the richness of the paradise" in which the air is balmy, and the landscape ever green; where life is a pastime, and music the only labour; where groves are interspersed with meadows and fountains; where nymphs sit playfully on the grass, or drink at cool springs."[50] Was ever such a gorgeous idyll? In the whole range of painted poetry can the like be found?

Yet let us be more precise in our analysis. Granted that the scene is one eminently adapted to Giorgione's poetic temperament, is the execution analogous to that which we have found in the preceding examples? No one will deny, I suppose, that there is a difference between the intensely refined forms of the Venus, or the earlier Hypsipyle, or the Daphne, and the coarser nudes in the Louvre picture. No one will deny a certain carelessness marks the delineation of form, no one will gainsay a frankly sensuous charm pervades the scene, a feeling which seems at first sight inconsistent with that reticence and modesty so conspicuous elsewhere. Yet I think all this is perfectly explicable on the basis of natural evolution. Exuberance of feeling is the logical outcome of a lifetime spent in an atmosphere of lyrical thought, and certainly Giorgione was not the sort of man to control those natural impulses, which grew stronger with advancing years. Both traditions of his death point in this direction; and, unless I am mistaken, the quality of his art, as well as its character, reflects this tendency. In his later years, 1508-10, he attains indeed a magnificence and splendour which dazzles the eye, but it is at the cost of that feeling of restraint which gives the earlier work such exquisite charm. In such a work as the Louvre "Concert," Giorgio has become Giorgione; he is riper in experience and richer in feeling, and his art assumes a corresponding exuberance of style, his forms become larger, his execution grows freer. Nay, more, that strain of carelessness is not wanting which so commonly accompanies such evolutions of character. And so this "Pastoral Symphony" becomes a characteristic production—that is, one which a man of Giorgione's temperament would naturally produce in the course of his developing. Peculiar, however, to an artist of genius is the subtlety of composition, which is held together by invisible threads, for nowhere else,

perhaps, has Giorgione shown a greater mastery of line. The diagonal line running from behind the nude figure on the left down to the foot so cunningly extended of the seated youth, is beautifully balanced by the line which is formed by the seated figure of the woman. The artist has deliberately emphasised this line by the curious posture of the legs. The figure, indeed, does not sit at all, but the balance of the composition is the better assured. What exquisite curves the standing woman presents! how cleverly the drapery continues the beautiful line, which Giorgione takes care not to break by placing the left leg and foot out of sight. How marvellously expressive, nay, how *inevitable* is the hand of the youth who is playing. Surely neither Campagnola nor any other second-rate artist was capable of such things!

THE THREE AGES OF MAN

The eighth picture cited by Morelli as, in his opinion, a genuine Giorgione, is the so-called "Three Ages of Man," in the Pitti at Florence—a damaged picture, but parts of which, as he says, "are still so splendid and so thoroughly Giorgionesque that I venture to ascribe it without hesitation to Giorgione."[51] The three figures are grouped naturally, and are probably portraits from life. The youth in the centre we have already met in the Kingston Lacy "Judgment of Solomon"; the man on the right recurs in the "Family Concert" at Hampton Court, and is strangely like the S. Maurice in the signed altar-piece at Berlin by Luzzi da Feltre.[52] But like though they be in type, in quality the heads in the "Three Ages" are immensely superior to those in the Berlin picture. The same models may well have served Giorgione and his friend and pupil Luzzi, or, as he is generally called, Morto da Feltre. A recent study of the few authenticated works by this feeble artist still at Feltre, his native place, forces me to dissent from the opinion that the Pitti "Three Ages" is the work of his hand.[53] Still less do I hold with the view that Lotto is the author.[54] Here, again, I believe Morelli saw further than other critics, and that his attribution is the right one. The simplicity, the apparently unstudied grouping, the refinement of type, the powerful expression, are worthy of the master; the play of light on the faces, especially on that of the youth, is most characteristic, and the peculiar chord of colour reveals a sense of originality such as no imitator would command. Unless I am mistaken, the man on the

right is none other than the Aeneas in the Vienna picture, and his hand with the pointing forefinger is such as we see two or three times over in the "Judgment of Solomon" and elsewhere. Certainly here it is awkwardly introduced, obviously to bring the figure into direct relation with the others; but Giorgione is by no means always supreme master of natural expression, as the hands in the "Adrastus and Hypsipyle" and Vienna pictures clearly show.

Here, for the first time, we meet Giorgione in those studies of human nature which are commonly called "conversation pieces," or "concerts"—natural groups of generally three people knit together by some common bond, which is usually music in one form or another. It is not the idyll of the "Pastoral Symphony," but akin to it as an expression of some exquisite moment of thought or feeling, an ideal instant "in which, arrested thus, we seem to be spectators of all the fulness of existence, and which is like some consummate extract or quintessence of life."[55] No one before Giorgione's time had painted such ideas, such poems without articulated story; and to have reached this stage of development presupposes a familiarity with set subjects such as a classic myth or mediaeval romance would offer for treatment. And so this "Three Ages" dates from his later years.

NYMPH AND SATYR

Another picture in the Pitti was also recognised by Morelli as Giorgione's work—"The Nymph pursued by a Satyr." Modern criticism seems undecided on the justice of this view, some writers inclining to the belief that this is a Giorgionesque production of Dosso Dossi, others preserving a discreet silence, or making frank avowal of their inability to decide. Nevertheless, I venture to agree with Morelli that "we have all the characteristics of an early (?) work of Giorgione—the type of the nymph with the low forehead, the charming arrangement of the hair upon the temples, the eyes placed near together, and the hand with tapering fingers."[56] The oval of the face recalls the "Knight of Malta," the high cranium and treatment of the hair such as we find in the Dresden "Venus" and elsewhere. The delicacy of modelling, the beauty of the features are far beyond Dosso's powers, who,

brilliant artist as he sometimes was, was of much coarser fibre than the painter of these figures. The difference of calibre between the two is well illustrated by comparing Giorgione's "Satyr" with Dosso's frankly vulgar "Buffone" in the Modena Gallery, or with those uncouth productions, also in the Pitti, the "S. John Baptist" and the "Bambocciate."[57] Were the repaints removed, I think all doubts as to the authorship would be set at rest, and the "Nymph and Satyr" would take its place among the slighter and more summary productions of Giorgione's brush.

MADONNA AND SAINTS

Only one sacred subject figures in the additions made by Morelli to the list of genuine Giorgiones. This is the small altar-piece at Madrid, with Madonna seated between S. Francis and S. Roch. Traditionally accredited to Pordenone, it has now received official recognition as a masterpiece of Giorgione, an attribution that, so far as I am aware, no one has seriously contested.[58] And, indeed, it is hard to conceive wherein any objection could possibly lie, for it is a typical creation of the master, *usque ad unguem*. Not only in types, colour, light and shade, and particularly in feeling, is the picture characteristic, but it again shows the artist leaving work unfinished, and again reveals the fact that the work grew in conception as it was actually being painted. I mean that the whole figure of S. Roch has been painted in over the rest, and that the S. Francis has also probably been introduced afterwards. I have little doubt that originally Giorgione intended to paint a simple Madonna and Child, and afterwards extended the scheme. The composition of three figures, practically in a row, is moreover most unusual, and contrary to that triangular scheme particularly favoured by the master, whereas the lovely sweep of Madonna's dress by itself creates a perfect design on a triangular basis. A great artist is here revealed, one whose feeling for line is so intense that he wilfully casts the drapery in unnatural folds in order to secure an artistic triumph. The working out of the dress within this line has yet to be done, the folds being merely suggested, and this task has been left whilst forwarding other parts. The freedom of touch and thinness of paint indicates how rapidly the artist worked. There is little deliberation apparent: indeed, the effect is that of hasty improvisation. Velasquez could not have painted the

stone on which S. Roch rests his foot with greater precision or more consummate mastery; the delicacy of flesh tints is amazing. The bit of landscape behind S. Roch (invisible in the reproduction), with its stately tree trunk rising solitary beside the hanging curtain, strikes a note of romance, fit accompaniment to the bizarre figure of the saint in his orange jerkin and blue leggings. How mysterious, too, is S. Francis!—rapt in his own thoughts, yet strangely human.

COPY OF A PORTION OF GIORGIONE'S "BIRTH OF PARIS"

We have now examined ten of the twelve pictures added, on Morelli's initiative, to the list of genuine works, and we have found very little, if any, serious opposition on the part of later writers to his views. Not so, however, with regard to the remaining two pictures. The first of these is a fragment in the gallery of Buda-Pesth, representing two figures in a landscape. All modern critics are agreed that Morelli has here mistaken an old copy after Giorgione for an original, a mistake we may readily pardon in consideration of the successful identification he has made of these figures with the Shepherds, in the composition seen and described by the Anonimo in 1525 as the "Birth of Paris," by Giorgione. This identification is fully confirmed by the engraving made by Th. von Kessel for the *Theatrum Pictorium*, which shows how these two figures are placed in the composition. Where, as in the present case, the original is missing, even a partial copy is of great value, for in it we can see the mind, if not the hand, of the great master. The Anonimo tells us this "Birth of Paris" was one of Giorgione's early works, a statement worthy of credence from the still Bellinesque stamp and general likeness of one of the Shepherds to the "Adrastus" in the Giovanelli picture. In pose, type, arrangement of hair, and in landscape this fragment is thoroughly Giorgionesque, and we have, moreover, those most characteristic traits, the pointing forefinger, and the unbroken curve of outline. The execution is, however, raw and crude, and entirely wanting in the magic quality of the master's own touch.[59]

THE SHEPHERD BOY.PORTRAIT OF A MAN

Finally, on Morelli's list figures the "Shepherd" at Hampton Court for the genuineness of which the critic would not absolutely vouch, as he had only seen it in a bad light. Perhaps no picture has been so strongly championed by an enthusiastic writer as has been this "Shepherd" by Mr Berenson, who strenuously advocates its title to genuineness.[60] Nevertheless several modern authorities remain unconvinced in presence of the work itself. The conception is unquestionably Giorgione's own, as we may see from a picture now in the Vienna Gallery, where this head is repeated in a representation of the young David holding the head of Goliath. The Vienna picture is, however, but a copy of a lost original by Giorgione, the existence of which is independently attested by Vasari.[61] Now, the question naturally arises, What relation does the Hampton Court "Shepherd" bear to this "David," Giorgione's lost original? It is possible, of course, that the master repeated himself, merely transforming the David into a Shepherd, or *vice versâ* and it is equally possible that some other and later artist adapted Giorgione's "David" to his own end, utilising the conception that is, and carrying it out in his own way. Arguing purely *a priori*, the latter possibility is the more likely, inasmuch as we know Giorgione hardly ever repeats a figure or a composition, whereas Titian, Cariani, and other later Venetian artists freely adopted Giorgione's ideas, his types, and his compositions for their own purposes. Internal evidence appears to me, moreover, to confirm this view, for the general style of painting seems to indicate a later period than 1510, the year of Giorgione's death. The flimsy folds, in particular, are not readily recognisable as the master's own. A comparison with a portrait in the Gallery of Padua reveals, particularly in this respect, striking resemblances. This fine portrait was identified by both Crowe and Cavalcaselle and by Morelli as the work of Torbido, and I venture to place the reproduction of it beside that of the "Shepherd" for comparison. It is not easy to pronounce on the technical qualities of either work, for both have suffered from re-touching and discolouring varnish, and the hand of the "Shepherd" is certainly damaged. Yet, whilst admitting that the evidence is inconclusive, I cannot refrain from suggesting Torbido's name as possible author of the "Shepherd," the more so as we know he carefully studied and formed his style upon Giorgione's work.[62] It is at least conceivable that he took Giorgione's "David with the Head of Goliath," and by a simple, and in this case peculiarly appropriate,

transformation, changed him into a shepherd boy holding a flute.

We have now taken all the pictures which either Crowe and Cavalcaselle or Morelli, or both, assign to Giorgione himself. There still remain, however, three or four works to be mentioned where these authorities hold opposite views which require some examination.

First and foremost comes the "Concert" in the Pitti Gallery, a work which was regarded by Crowe and Cavalcaselle not only as a genuine example of Giorgione's art, but as "not having its equal in any period of Giorgione's practice. It gives," they go on, "a just measure of his skill, and explains his celebrity."[63] Morelli, on the contrary, holds: "It has unfortunately been so much damaged by a restorer that little enough remains of the original, yet from the form of the hands and of the ear, and from the gestures of the figures, we are led to infer that it is not a work of Giorgione, but belongs to a somewhat later period. If the repaint covering the surface were removed we should, I think, find that it is an early work by Titian."[64] Where Morelli hesitated his followers have decided, and accordingly, in Mr. Berenson's list, in Mr. Claude Phillips' "Life of Titian," and in the latest biography on that master, published by Dr. Gronau, we find the "Concert" put down to Titian. On the other hand, Dr. Bode, Signor Conti in his monograph on Giorgione, M. Müntz, and the authorities in Florence support the traditional view that the "Concert" is a masterpiece of Giorgione.

THE CONCERT

Which view is the right one? To many this may appear an academic discussion of little value, for, *ipso facto*, the quality of the work is admitted by all. The picture is a fine thing, in spite of its imperfect condition, and what matter whether Titian or Giorgione be the author? But to this sort of argument it may be said that until we do know what is Giorgione's work and what is not, it is impossible to gauge accurately the nature and scope of his art, or to reach through that channel the character of the artist behind his work. In the case of Giorgione and Titian, the task of drawing the dividing line is one of unusual difficulty, and a long and careful study of the question has convinced me that this will have to be done in a way that modern criticism has not yet attempted. From the very earliest days the two have

been so inextricably confused that it will require a very exhaustive re-examination of all the evidence in the light of modern discoveries, documentary and pictorial, coupled, I am afraid, with the recognition of the fact that much modern criticism on this point has been curiously at fault. This is neither the time nor the place to discuss the question of Titian's early work, but I feel sure that this chapter of art history has yet to be correctly written.[65] One of the determining factors in the discussion will be the authorship of the Pitti "Concert," for our estimate of Giorgione or Titian must be coloured appreciably by the recognition of such an epoch-making picture as the work of one or the other.

It is, therefore, peculiarly unfortunate that the two side figures in this wonderful group are so rubbed and repainted as almost to defy certainty of judgment. In conception and spirit they are typically Giorgionesque, and Morelli, I imagine, would scarcely have made the bold suggestion of Titian's authorship but for the central figure of the young monk playing the harpsichord. This head stands out in grand relief, being in a far purer state of preservation than the rest, and we are able to appreciate to some extent the extraordinarily subtle modelling of the features, the clear-cut contours, the intensity of expression. The fine portrait in the Louvre, known as "L'homme au gant," an undoubted early work of Titian, is singularly close in character and style, as was first pointed out by Mr. Claude Phillips,[66] and it was this general reminiscence, more than points of detail in an admittedly imperfect work that seemingly induced Morelli to suggest Titian's name as possible author of the "Concert." Nevertheless, I cannot allow this plausible comparison to outweigh other and more vital considerations. The subtlety of the composition, the bold sweep of diagonal lines, the way the figure of the young monk is "built up" on a triangular design, the contrasts of black and white, are essentially Giorgione's own. So, too, is the spirit of the scene, so telling in its movement, gesture, and expression. Surely it is needless to translate all that is most characteristic of Giorgione in his most personal expression into a "Giorgionesque" mood of Titian. No, let us admit that Titian owed much to his friend and master (more perhaps than we yet know), but let us not needlessly deprive Giorgione of what is, in my opinion at least, the great creation of his maturer years, the Pitti "Concert." I am inclined to place it about 1506-7, and to regard it as the earliest and finest expression in

Venetian art of that kind of genre painting of which we have already studied another, though later example, "The Three Ages" (in the Pitti). The second work where Crowe and Cavalcaselle hold a different view from Morelli is a "Portrait of a Man" in the Gallery of Rovigo (No. 11). The former writers declare that it, "perhaps more than any other, approximates to the true style of Giorgione."[67] With such praise sounding in one's ears it is somewhat of a shock to discover that this "grave and powerfully wrought creation" is a miniature 7 by 6 inches in size. Such an insignificant fragment requires no serious consideration; at most it would seem only to be a reduced copy after some lost original. Morelli alludes to it as a copy after Palma, but one may well doubt whether he is not referring to another portrait in the same gallery (No. 123). Be that as it may, this "Giorgione" miniature is sadly out of place among genuine pieces of the master.[68]

THE ADORATION OF THE MAGI

One other picture, of special interest to English people, is in dispute. By Crowe and Cavalcaselle "The Adoration of the Magi," now in the National Gallery (No. 1160), is attributed to the master himself; by Morelli it was assigned to Catena.[69] This brilliant little panel is admittedly by the same hand that painted the Beaumont "Adoration of the Shepherds," and yet another picture presently to be mentioned. We have already agreed to the propriety of attribution in the former case; it follows, therefore, that here also Giorgione's name is the correct one, and his name, we are glad to see, has recently been placed on the label by the Director of the Gallery.

This beautiful little panel, which came from the Leigh Court Collection, under Bellini's name, has much of the depth, richness, and glow which characterises the Beaumont picture, although the latter is naturally more attractive, owing to the wonderful landscape and the more elaborate chiaroscuro. The figures are Bellinesque, yet with that added touch of delicacy and refinement which Giorgione always knows how to impart. The richness of colouring, the depth of tone, the glamour of the whole is far superior to anything that we can point to with certainty as Catena's work; and no finer example of his "Giorgionesque" phase is to be found than the sumptuous "Warrior adoring the Infant Christ," which hangs close by, whilst

his delicate little "S. Jerome in his Study," also in the same room, challenges comparison. Catena's work seems cold and studied beside the warmth and spontaneity of Giorgione's little panel, which is, indeed, as Crowe and Cavalcaselle assert, "of the most picturesque beauty in distribution, colour, and costume."[70] It must date from before 1500, probably just before the Beaumont "Nativity," and proves how, even at that early time, Giorgione's art was rapidly maturing into full splendour.

The total list of genuine works so far amounts to but twenty-three. Let us see if we can accept a few others which later writers incline to attribute to the master. I propose to limit the survey strictly to those pictures which have found recognised champions among modern critics of repute, for to challenge every "Giorgione" in public and private collections would be a Herculean task, well calculated to provoke an incredulous smile!

PAGE OF VANDYCK'S SKETCH-BOOK, WITH GIORGIONE'S "CHRIST BEARING THE CROSS," IN THE CHURCH OF S. ROCCO, VENICE

Mr. Berenson, in his *Venetian Painters*, includes two other pictures in an extremely exclusive list of seventeen genuine Giorgiones. These are both in Venice, "The Christ bearing the Cross" (in S. Rocco), and "The Storm calmed by S. Mark" (in the Academy). The question whether or no we are to accept the former of these pictures has its origin in a curious contradiction of Vasari, who, in the first edition of his Lives (1550), names Giorgione as the painter, whilst in the second (1565), he assigns the authorship to Titian. Later writers follow the latter statement, and to this day the local guides adhere to this tradition. That the attribution to Giorgione, however, was still alive in 1620-5, is proved by the sketch of the picture made by the young Van Dyck during his visit to Italy, for he has affixed Giorgione's name to it, and not that of Titian.[71] I am satisfied that this tradition is correct. Giorgione, and not Titian, painted the still lovely head of Christ, and Giorgione, not Titian, drew the arm and hand of the Jew who is dragging at the rope. Characteristic touches are to be seen in the turn of the head, the sloping axis of the eyes, and especially the fine oval of the face, and bushy hair. This is the type of Giorgione's Christ; "The Tribute Money" (at Dresden) shows Titian's.

Unfortunately the panel has lost all its tone, all its glow, and most of its original colour, and we can scarcely any longer admire the picture which, in Vasari's graphic language, "is held in the highest veneration by many of the faithful, and even performs miracles, as is frequently seen"; and again (in his *Life of Titian*), "it has received more crowns as offerings than have been earned by Titian and Giorgione both, through the whole course of their lives."

The other picture included by Mr. Berenson in his list is the large canvas in the Venice Academy, with "The Storm calmed by S. Mark." According to this critic it is a late work, finished, in small part, by Paris Bordone. In my opinion, it would be far wiser to withhold definite judgment in a case where a picture has been so entirely repainted. Certainly, in its present state, it is impossible to recognise Giorgione's touch, whilst the glaring red tones of the flesh and the general smeariness of the whole render all enjoyment out of question. I am willing to admit that the conception may have been Giorgione's, although even then it would stand alone as evidence of an imagination almost Michelangelesque in its *terribilità*. Zanetti (1760) was the first to connect Giorgione's name with this canvas, Vasari bestowing inordinate praise upon it as the work of Palma Vecchio! It only remains to add that this is the companion piece to the well-known "Fisherman presenting the Ring to the Doge," by Paris Bordone, which also hangs in the Venice Academy. Both illustrate the same legend, and both originally hung in the Scuola di S. Marco.

FRONTS OF TWO CASSONES, WITH MYTHOLOGICAL SCENES

Finally, two *cassone* panels in the gallery at Padua have been acclaimed by Signor Venturi as the master's own,[72] and with that view I am entirely agreed. The stories represented are not easily determinable (as is so often the case with Giorgione), but probably refer to the legends of Adonis.[73] The splendour of colour, the lurid light, the richness of effect, are in the highest degree impressive. What artist but Giorgione would have so revelled in the glories of the evening sunset, the orange horizon, the distant blue hills? The same gallery affords several instances of similar decorative pieces by other Venetian artists which serve admirably to show the great gulf fixed in quality

between Giorgione's work and that of the Schiavones, the Capriolis, and others who imitated him.[74]

NOTES:

[11]

Oxford Lecture, reported in the *Pall Mall Gazette*, Nov. 10, 1884.

[12]

See *postea*, p. 63.

[13]

Bellini adopted it later in his S. Giov. Crisostomo altar-piece of 1513.

[14]

All the more surprising is it that it receives no mention from Vasari, who merely states that the master worked at Castelfranco.

[15]

I unhesitatingly adopt the titles recently given to these pictures by Herr Franz Wickhoff (*Jahrbuch der Preussischen Kunstsammlungen*, Heft. i. 1895), who has at last succeeded in satisfactorily explaining what has puzzled all the writers since the days of the Anonimo.

[16]

Statius: *Theb.* iv. 730 *ff.* See p. 135.

[17]

Aen. viii. 306-348.

[18]

Fry: *Giovanni Bellini*, p. 39.

[19]

ii. 214.

[20]

Ridolfi mentions the following as having been painted by Giorgione:—"The Age of Gold," "Deucalion and Pyrrha," "Jove hurling Thunderbolts at the Giants," "The Python," "Apollo and Daphne," "Io changed into a Cow," "Phaeton, Diana, and Calisto," "Mercury stealing Apollo's Arms," "Jupiter and Pasiphae," "Cadmus sowing the Dragon's Teeth," "Dejanira raped by Nessus," and various episodes in the life of Adonis.

[21]

In the Venice Academy.

[22]

Archivio, Anno VI., where reproductions of the two are given side by side, *fasc.* vi. p. 412.

[23]

The Berlin example (by the Pseudo-Basaiti) is reproduced in the Illustrated Catalogue of the recent exhibition of Renaissance Art at Berlin; the Rovigo version (under Leonardo's name!) is possibly by Bissolo.

Two other repetitions exist, one at Stuttgart, the other in the collection of Sir William Farrer. (Venetian Exhibition, New Gallery, 1894, No. 76.)

[24]

Gentile Bellini's three portraits in the National Gallery (Nos. 808, 1213, 1440) illustrate this growing tendency in Venetian art; all three probably date from the first years of the sixteenth century. Gentile died in 1507.

[25]

Berenson: *Venetian Painters*, 3rd edition.

[26]

Daily Telegraph, December 29th, 1899.

[27]

Even the so-called Pseudo-Basaiti has been separated and successfully diagnosed.

[28]

1895 Catalogue.

[29]

See Appendix, where the letters are printed in full.

[30]

Crowe and Cavalcaselle, ii. 142, and note.

[31]

Giorgione painted in fresco in the portico of this palace. Zanetti has preserved the record of a figure said to be "Diligence," in his print published in 1760.

[32]

See Byron's *Life and Letters*, by Thomas Moore, p. 705.

[33]

See Berenson's *Venetian Painters*, illustrated edition.

[34]

Morelli, ii. 219.

[35]

See p. 32 for a possible explanation of these letters.

[36]

ii. 218

[37]

It has been suggested to me by Dr. Williamson that the letters may possibly be intended for ZZ (=Zorzon). In old MSS. the capital Z is sometimes made thus **D** or **V**.

[38]

i. 248.

[39]

The methods by which he arrived at his conclusion are strangely at variance with those he so strenuously advocates, and to which the name of Morellian has come to be attached.

[40]

Reproduced in *Venetian Art at the New Gallery*, under Giorgione's name, but unanimously recognised as a work of Licinio.

[41]

i. 249.

[42]

Dr. Bode and Signor Venturi both recognise it as Giorgione's work.

[43]

To what depths of vulgarity the Venetian School could sink in later times, Palma Giovane's "Venus" at Cassel testifies.

[44]

Repertorium für Kunstwissenschaft. 1896. xix. Band. 6 Heft.

[45]

North American Review, October 1899.

[46]

It was photographed by Braun with this attribution.

[47]

Catena has adopted this Giorgionesque conception in his "Judith" in

the Querini-Stampalia Gallery in Venice.

[48]
See *Gazette des Beaux Arts*, 1897, tom, xviii. p. 279.

[49]
See *Gazette des Beaux Arts*, 1893, tom. ix. p. 135 (Prof. Wickhoff); 1894, tom. xii. p. 332 (Dr. Gronau); and *Repertorium für Kunstwissenschaft*, tom. xiv. p. 316 (Herr von Seidlitz).

[50]
Crowe and Cavalcaselle, ii. 147.

[51]
ii. 217.

[52]
Dr. Gronau points this out in *Rep.* xviii. 4, p. 284.

[53]
See *Guide to the Italian Pictures* at Hampton Court, by Mary Logan, 1894.

[54]
Official Catalogue, and Crowe and Cavalcaselle, ii. 502.

[55]
Pater: *The Renaissance*, p. 158.

[56]
ii. 219.

[57]
The execution of this grotesque picture is probably due to Girolamo da Carpi, or some other assistant of Dosso.

[58]
Crowe and Cavalcaselle, ii. 292, unaccountably suggested Francesco Vecellio (!) as the author.

[59]
The subject is derived from a passage in the *De Divinitate* of Cicero, as Herr Wickhoff has pointed out.

[60]
See *Venetian Painting at the New Gallery*. 1895.

[61]
Unless we are to suppose that Vasari mistook a copy for an original.

[62]

Francesco Torbido, called "il Moro," born about 1490, and still living in 1545. Vasari states that he actually worked under Giorgione. Signed portraits by him are in the Brera, at Munich, and Naples. Palma Vecchio also deserves serious consideration as possible author of the "Shepherd Boy."

[63]

Crowe and Cavalcaselle, ii. 144.

[64]

Morelli, ii. 212.

[65]

See Appendix, p. 123.

[66]

Quoted by Morelli, ii. 212, note.

[67]

Crowe and Cavalcaselle, ii. 155.

[68]

Crowe and Cavalcaselle also cite a portrait in the Casa Ajata at Crespano; as I have never seen this piece I cannot discuss it. It was apparently unknown to Morelli, nor is it mentioned by other critics.

[69]

Morelli, ii. 205.

[70]

Crowe and Cavalcaselle, ii. 128. Mr. Claude Phillips, in the *Gazette des Beaux Arts*, 1884, p. 286, rightly admits Giorgione's authorship.

[71]

This sketch is to be found in Van Dyck's note-book, now in possession of the Duke of Devonshire at Chatsworth. It is here reproduced, failing an illustration of the original picture, which the authorities in Venice decline to have made. (A good reproduction has now (1903) been made by Anderson of Rome.)

[72]

Archivio Storico, vi. 409.

[73]

Ridolfi tells us Giorgione painted, among a long list of decorative pieces, "The Birth of Adonis," "Venus and Adonis embracing," and "Adonis

killed by the Boar." It is possible he was alluding to these very *cassone* panels.

[74]

The other important additions made by Signor Venturi in his recent volume, *La Galleria Crespi*, are alluded to *in loco*, further on. I am delighted to find some of my own views anticipated in a wholly independent fashion.

CHAPTER III

INTERMEDIATE SUMMARY

It is necessary for anyone who seeks to recover the missing or unidentified works of an artist like Giorgione, first to define his conception of the artist based upon a study of acknowledged materials. The preceding chapter has been devoted to a survey of the best authenticated pictures, the evidence for the genuineness of which is, as we have seen, largely a matter of personal opinion. Nevertheless there is, on the whole, a unanimity of judgment sufficient to warrant our drawing several inferences as to the general character of Giorgione's work, and to attempt a chronological arrangement of the twenty-six pictures here accepted as genuine.

The first and most obvious fact then to be noted is the amazing variety of subjects handled by the master. Religious paintings, whether altar-pieces or easel pictures of a devotional character, are interspersed with mediaeval allegories, genre subjects, decorative *cassone* panels, portraiture, and purely lyrical "Fantasiestücke," corresponding somewhat with the modern "Landscape with Figures." Truly an astonishing range! Giorgione, as we have seen, could not have been more than eighteen years in active practice, yet in that short time he gained successes in all these various fields. His many-sidedness shows him to have been a man of wide sympathies, whilst the astonishing rapidity of his development testifies to the precocity of his talent. His versatility and his precocity are, in fact, the two most prominent characteristics to be borne in mind in judging his art, for much that appears at first sight incongruous, if not utterly irreconcilable, can be explained on this basis. For versatility and precocity in an artist are qualities invariably attended by unevenness of workmanship, as we see in the cases of Keats and Schubert, who were gifted with the lyrical temperament and powers of expression in poetry and music in corresponding measure to Giorgione in painting. It would show want of critical acumen to expect from Keats the consistency of Milton, or that Schubert should keep the unvarying high level

of Beethoven, and it is equally unreasonable to exact from Giorgione the uniform excellence which characterises Titian. I do not propose at this point to work out the comparison between the painter, the musician, and the poet; this must be reserved until the final summing-up of Giorgione as artist, when we have examined all his work. But this point I do insist on, that from the very nature of things Giorgione's art is, and must be, uneven, that whilst at times it reaches sublime heights, at other times it attains to a level of only average excellence.

And so the criticism which condemns a picture claiming to be Giorgione's because "it is not *good* enough for him," does not recognise the truth that for all that it may be *characteristic*, and, consequently, perfectly authentic. Modern criticism has been apt to condemn because it has expected too much; let us not blind our eyes to the weaknesses, even to the failures of great men, who, if they lose somewhat of the hero in our eyes, win our sympathy and our love the more for being human.

I have spoken of Giorgione's versatility, his precocity, and the natural inequality of his work. There is another characteristic which commonly exists when these qualities are found united, and that is Productiveness. Giorgione, according to all analogy, must have produced a mass of work. It is idle to assert, as some modern writers have done, that at the utmost his easel pictures could have been but few, because most of his short life was devoted to painting frescoes, which have perished. It is true that Giorgione spent time and energy over fresco painting, and from the very publicity of such work as the frescoes on the Fondaco de' Tedeschi, he came to be widely known in this direction, but it is infinitely probable that his output in other branches was enormous. The twenty-six pictures we have already accepted, plus the lost frescoes, cannot possibly represent the sum-total of his artistic activities, and to say that everything else has disappeared is, as I shall try to show, not correct. We know, moreover, from the Anonimo (who was almost Giorgione's contemporary) that many pictures existed in his day which cannot now be traced,[75] and if we add these and some of the others cited by Vasari and Ridolfi (without assuming that every one was a genuine example), it goes to prove that Giorgione did paint a good number of easel pictures. But the evidence of the twenty-six themselves is conclusive. They illustrate so many different phases, they stand sometimes so widely apart, that

intermediate links are necessarily implied. Moreover, as Giorgione's influence on succeeding artists is allowed by all writers, a considerable number of his easel pictures must have been in circulation, from which these imitators drew inspiration, for he certainly never kept, as Bellini did, a body of assistants and pupils to hand on his teaching, and disseminate his style.

Productiveness must then have been a feature of his art, and as so few pictures have as yet come to be accepted as genuine, the majority must have perished or been lost to sight for the time. That much yet remains hidden away in private possession I am fully persuaded, especially in England and in Italy, and one day we may yet find the originals of the several old copies after Giorgione which I enumerate elsewhere.[76] In some cases I believe I have been fortunate enough to detect actually missing originals, and occasionally restore to Giorgione pieces that parade under Titian's name. Much, however, yet remains to be done, and the research work now being systematically conducted in the Venetian archives by Dr. Gustav Ludwig and Signor Pietro Paoletti may yield rich results in the discovery of documents relating to the master himself, which may help us to identify his productions, and possibly confirm some of the conjectures I venture to make in the following chapters.[77]

But before proceeding to examine other pictures which I am persuaded really emanate from Giorgione himself, let us attempt to place in approximate chronological order the twenty-six works already accepted as genuine, for, once their sequence is established, we shall the more readily detect the lacunae in the artist's evolution, and so the more easily recognise any missing transitional pieces which may yet exist.

The earliest stage in Giorgione's career is naturally marked by adherence to the teaching and example of his immediate predecessors. However precocious he may have been, however free from academic training, however independent of the tradition of the schools, he nevertheless clearly betrays an artistic dependence, above all, on Giovanni Bellini. The "Christ bearing the Cross" and the two little pictures in the Uffizi are direct evidence of this, and these, therefore, must be placed quite early in his career. We should not be far wrong in dating them 1493-5. Carpaccio's influence is also apparent, as we have already noticed, and through this channel Giorgione's art connects with the more archaic style of Gentile Bellini,

Giovanni's elder brother. Thus in him are united the quattrocentist tradition and the fresher ideals of the cinquecento, which found earliest expression in Giambellini's Allegories of about 1486-90. The poetic element in these works strongly appealed to Giorgione's sensitive nature, and we find him developing this side of his art in the Beaumont "Adoration," and the National Gallery "Epiphany," both of which are clearly early productions. But there is a gap of a few years between the Uffizi pictures and the London ones, for the latter are maturer in every way, and it is clear that the interval must have been spent in constant practice. Yet we cannot point with certainty to any of the other pictures in our list as standing midway in development, and here it is that a lacuna exists in the artist's career. Two or three years, possibly more, remain unaccounted for, just at a period, too, when the young artist would be most impressionable. I am inclined to think that he may have painted the "Birth of Paris" during these years, but we have only the copy of a part of the composition to go by, and the statement of the Anonimo that the picture was one of Giorgione's early works.

The "Adrastus and Hypsipyle" must also be a youthful production prior to 1500, and in the direction of portraiture we have the Berlin "Young Man," which, for reasons already given, must be placed quite early. It is not possible to assign exact dates to any of these works, all that can be said with any certainty is that they fall within the last decade of the fifteenth century, and illustrate the rapid development of Giorgione's art up to his twenty-fourth year.

A further stage in his evolution is reached in the Castelfranco "Madonna," the first important undertaking of which we have some record. Tradition connects the painting of this altar-piece with an event of the year 1504, the death of the young Matteo Costanzo, whose family, so it is said, commissioned Giorgione to paint a memorial altar-piece, and decorate the family chapel at Castelfranco with frescoes. Certain it is that the arms of the Costanzi appear in the picture, but the evidence which connects the commission with the death of Matteo seems to rest mainly on his alleged likeness to the S. Liberale in the picture, a theory, we may remark, which is quite consistent with Matteo being still alive. Considering the extraordinary rapidity of the artist's development, it would be more natural to place the execution of this work a year or two earlier than 1504, but, in any case, we

may accept it as typical of Giorgione's style in the first years of the century. The "Judith" (at St. Petersburg), as we have already seen, probably immediately precedes it, so that we get two masterpieces approximately dated.

In the field of portraiture Giorgione must have made rapid strides from the very first. Vasari states that he painted the portraits of the great Consalvo Ferrante, and of one of his captains, on the occasion of their visit to the Doge Agostino Barberigo. Now this event presumably took place in 1500,[78] so that, at that early date, he seems already to have been a portrait painter of repute. Confirmatory evidence of this is furnished by the statement of Ridolfi, that Giorgione took the portrait of Agostino Barberigo himself.[79] Now the Doge died in 1500, so that if Giorgione really painted him, he could not have been more than twenty-three years of age at the time, an extraordinarily early age to have been honoured with so important a commission; this fact certainly presupposes successes with other patrons, whose portraits Giorgione must have taken during the years 1495-1500. I hope to be able to identify two or three of these, but for the moment we may note that by 1500 Giorgione was a recognised master of portraiture. The only picture on our list likely to date from the period 1500-1504 is the "Knight of Malta," the "Young Man" (at Buda-Pesth) being later in execution.[80]

From 1504 on, the rapid rate of progress is more than fully maintained. Only six years remain of the artist's short life, yet in that time he rose to full power, and anticipated the splendid achievements of Titian's maturity some forty years later. First in order, probably, come the "Venus" (Dresden) and the "Concert" (Pitti), both showing originality of conception and mastery of handling. The date of the frescoes on the Fondaco de' Tedeschi is known to be 1507-8,[81] but, as nothing remains but a few patches of colour in one spot high up over the Grand Canal, we have no visible clue to guide us in our estimate of their artistic worth. Vasari's description, and Zanetti's engraving of a few fragments (done in 1760, when the frescoes were already in decay), go to prove that Giorgione at this period studied the antique, "commingling statuesque classicism and the flesh and blood of real life."[82]

At this period it is most probable we must place the "Judgment of Solomon" (at Kingston Lacy), possibly, as I have already pointed out, the

very work commissioned by the State for the audience chamber of the Council, on which, as we know from documents, Giorgione was engaged in 1507 and 1508. It was never finished, and the altogether exceptional character of the work places it outside the regular course of the artist's development. It was an ambitious venture in an unwonted direction, and is naturally marked and marred by unsatisfactory features. Giorgione's real powers are shown by the "Pastoral Symphony" (in the Louvre), and the "Portrait of the Young Man" (at Buda-Pesth), productions dating from the later years 1508-10. The "Three Ages" (in the Pitti) may also be included, and if Giorgione conceived and even partly executed the "Storm calmed by S. Mark" (Venice Academy), this also must be numbered among his last works.

Morelli states: "It was only in the last six years of his short life (from about 1505-11) that Giorgione's power and greatness became fully developed."[83] I think this is true in the sense that Giorgione was ever steadily advancing towards a fuller and riper understanding of the world, that his art was expanding into a magnificence which found expression in larger forms and richer colour, that he was acquiring greater freedom of touch, and more perfect command of the technical resources of his art. But sufficient stress is not laid, I think, upon the masterly achievement of the earlier times; the tendency is to refer too much to later years, and not recognise sufficiently the prodigious precocity before 1500. One is tempted at times to question the accuracy of Vasari's statement that Giorgione died in his thirty-fourth year, which throws his birth back only to 1477. Some modern writers disregard this statement altogether, and place his birth "before 1477."[84] Be this as it may, it does not alter the fact that by 1500 Giorgione had already attained in portraiture to the highest honours, and in this sphere, I believe, he won his earliest successes. My object in the following chapter will be to endeavour to point out some of the very portraits, as yet unidentified, which I am persuaded were produced by Giorgione chiefly in these earlier years, and thus partly to fill some of the lacunae we have found in tracing his artistic evolution.

NOTES:

[75]

A list of these is given at p. 138.

[76]

Vide List of Works, pp. 124-137.

[77]

The results of these archivistic researches are being published in the *Repertorium für Kunstwissenschaft*.

[78]

For the evidence, see *Magazine of Art*, April 1893.

[79]

Meravig, i. 126.

[80]

Vasari saw Giorgione's portrait of the succeeding Doge Leonardo Loredano (1501-1521).

[81]

See Crowe and Cavalcaselle, ii. 141.

[82]

Crowe and Cavalcaselle, *ibid*.

[83]

ii. 213. We now know that he died in 1510.

[84]

Crowe and Cavalcaselle, ii. 119. Bode: *Cicerone*.

CHAPTER IV

ADDITIONAL PICTURES—PORTRAITS

Vasari, in his *Life of Titian*, in the course of a somewhat confused account of the artist's earliest years, tells us how Titian, "having seen the manner of Giorgione, early resolved to abandon that of Gian Bellino, although well grounded therein. He now, therefore, devoted himself to this purpose, and in a short time so closely imitated Giorgione that his pictures were sometimes taken for those of that master, as will be related below." And he goes on: "At the time when Titian began to adopt the manner of Giorgione, being then not more than eighteen, he took the portrait of a gentleman of the Barberigo family who was his friend, and this was considered very beautiful, the colouring being true and natural, and the hair so distinctly painted that each one could be counted, as might also the stitches[85] in a satin doublet, painted in the same work; in a word, it was so well and carefully done, that it would have been taken for a picture by Giorgione, if Titian had not written his name on the dark ground." Now the statement that Titian began to imitate Giorgione at the age of eighteen is inconsistent with Vasari's own words of a few paragraphs previously: "About the year 1507, Giorgione da Castel Franco, not being satisfied with that mode of proceeding (i.e. 'the dry, hard, laboured manner of Gian Bellino, which Titian also acquired'), began to give to his works an unwonted softness and relief, painting them in a very beautiful manner.... Having seen the manner of Giorgione, Titian now devoted himself to this purpose," etc. In 1507 Titian was thirty years old,[86] not eighteen, so that both statements cannot be correct. Now it is highly improbable that Titian had already discarded the manner of Bellini as early as 1495, at the age of eighteen, and had so identified himself with Giorgione that their work was indistinguishable. Everything, on the contrary, points to Titian's evolution being anything but rapid; in fact, so far as records go, there is no mention of his name until he painted the façade of the Fondaco de' Tedeschi in company with Giorgione in 1507. It is infinitely more probable that Vasari's first statement is the more

reliable—viz. that Titian began to adopt Giorgione's manner about the year 1507, and it follows, therefore, that the portrait of the gentleman of the Barberigo family, if by Titian, dates from this time, and not 1495.

PORTRAIT OF A GENTLEMAN

Now there is a picture in the Earl of Darnley's Collection at Cobham Hall which answers pretty closely to Vasari's description. It is a supposed portrait of Ariosto by Titian, but it is as much unlike the court poet of Ferrara as the portrait in the National Gallery (No. 636) which, with equal absurdity, long passed for that of Ariosto, a name now wisely removed from the label. This magnificent portrait at Cobham was last exhibited at the Old Masters in 1895, and the suggestion was then made that it might be the very picture mentioned by Vasari in the passage quoted above.[87] I believe this ingenious suggestion is correct, and that we have in the Cobham "Ariosto" the portrait of one of the Barberigo family said to have been painted by Titian in the manner of Giorgione. "Thoroughly Giorgionesque," says Mr. Claude Phillips, in his *Life of Titian*, "is the soberly tinted yet sumptuous picture in its general arrangement, as in its general tone, and in this respect it is the fitting companion and the descendant of Giorgione's 'Antonio Broccardo' at Buda-Pesth, of his 'Knight of Malta' at the Uffizi. Its resemblance, moreover, is, as regards the general lines of the composition, a very striking one to the celebrated Sciarra 'Violin-Player,' by Sebastiano del Piombo.... The handsome, manly head has lost both subtlety and character through some too severe process of cleaning, but Venetian art has hardly anything more magnificent to show than the costume, with the quilted sleeve of steely, blue-grey satin, which occupies so prominent a place in the picture." Its Giorgionesque character is therefore recognised by this writer, as also by Dr. Georg Gronau, in his recent *Life of Titian* (p. 21), who significantly remarks, "Its relation to the 'Portrait of a Young Man' by Giorgione, at Berlin, is obvious."

It is a pity that both these discerning writers of the modern school have not gone a little further and seen that the picture before them is not only Giorgionesque, but by Giorgione himself. The mistake of confusing Titian and Giorgione is as old as Vasari, who, *misled by the signature*, naïvely

remarks, "It would have been taken for a picture by Giorgione if Titian had not written his name on the dark ground (in ombra)." *Hinc illae lacrimae!* Let us look into this question of signatures, the ultimate and irrevocable proof in the minds of the innocent that a picture must be genuine. Titian's methods of signing his well-authenticated works varied at different stages of his career. The earliest signature is always "Ticianus," and this is found on works dating down to 1522 (the "S. Sebastian" at Brescia). The usual signature of the later time is "Titianus," probably the earliest picture with it being the Ancona altar-piece of 1520. "Tician" is found only twice. Now, without necessarily condemning every signature which does not accord with this practice, we must explain any apparent irregularity, such, for instance, as the "Titianus F." on the Cobham Hall picture. This form of signature points to the period after 1520, a date manifestly inconsistent with the style of painting. But there is more than this to arouse suspicion. The signature has been painted over another, or rather, the F. (= fecit)[88] is placed over an older V, which can still be traced. A second V appears further to the right. It looks as if originally the balustrade only bore the double V, and that "Titianus F." were added later. But it was there in Vasari's day (1544), so that we arrive at the interesting conclusion that Titian's signature must have been added between 1520 and 1544—that is, in his own lifetime. This singular fact opens up a new chapter in the history of Titian's relationship to Giorgione, and points to practices well calculated to confuse historians of a later time, and enhance the pupil's reputation at the expense of the deceased master. Not that Titian necessarily appropriated Giorgione's work, and passed it off as his own, but we know that on the latter's death Titian completed several of his unfinished pictures, and in one instance, we are told, added a Cupid to Giorgione's "Venus." It may be that this was the case with the "Ariosto," and that Titian felt justified in adding his signature on the plea of something he did to it in after years; but, explain this as we may, the important point to recognise is that in all essential particulars the "Ariosto" is the creation not of Titian, but of Giorgione. How is this to be proved? It will be remembered that when discussing whether Giorgione or Titian painted the Pitti "Concert," the "Giorgionesque" qualities of the work were so obvious that it seemed going out of the way to introduce Titian's name, as Morelli did, and ascribe the picture to him in a Giorgionesque phase. It is just the same here. The

conception is typically Giorgione's own, the thoughtful, dreamy look, the turn of the head, the refinement and distinction of this wonderful figure alike proclaim him; whilst in the workmanship the quilted satin is exactly paralleled by the painting of the dress in the Berlin and Buda-Pesth portraits. Characteristic of Giorgione but not of Titian, is the oval of the face, the construction of the head, the arrangement of the hair. Titian, so far as I am aware, never introduces a parapet or ledge into his portraits, Giorgione nearly always does so; and finally we have the mysterious VV which is found on the Berlin portrait, and (half-obliterated) on the Buda-Pesth "Young Man." In short, no one would naturally think of Titian were it not for the misleading signature, and I venture to hope competent judges will agree with me that the proofs positive of Giorgione's authorship are of greater weight than a signature which—for reasons given—is not above suspicion.[89]

Before I leave this wonderful portrait of a gentleman of the Barberigo family (so says Vasari), a word as to its date is necessary. The historian tells us it was painted by Titian at the age of eighteen. Clearly some tradition existed which told of the youthfulness of the painter, but may we assume that Giorgione was only eighteen at the time? That would throw the date back to 1495. Is it possible he can have painted this splendid head so early in his career? The freedom of handling, and the mastery of technique certainly suggests a rather later stage, but I am inclined to believe Giorgione was capable of this accomplishment before 1500. The portrait follows the Berlin "Young Man," and may well take its place among the portraits which, as we have seen, Giorgione must have painted during the last decade of the century prior to receiving his commission to paint the Doge. And in this connection it is of special interest to find the Doge was himself a Barberigo. May we not conclude that the success of this very portrait was one of the immediate causes which led to Giorgione obtaining so flattering a commission from the head of the State?

I mentioned incidentally that four repetitions of the "Ariosto" exist, all derived presumably from the Cobham original. We have a further striking proof of the popularity of this style of portraiture in a picture belonging to Mr. Benson, exhibited at the Venetian Exhibition, New Gallery, 1894-5, where the painter, whoever he may be, has apparently been inspired by Giorgione's original. The conception is wholly Giorgionesque, but the

hardness of contour and the comparative lack of quality in the touch betrays another and an inferior hand. Nevertheless the portrait is of great interest, for could we but imagine it as fine in execution as in conception we should have an original Giorgione portrait before us. The features are curiously like those of the Barberigo gentleman.

In his recently published *Life of Titian*, Dr. Gronau passes from the consideration of the Cobham Hall picture immediately to that of the "Portrait of a Lady," known as "La Schiavona," in the collection of Signor Crespi in Milan. In his opinion these two works are intimately related to one another, and of them he significantly writes thus: "The influence of Giorgione upon Titian" (to whom he ascribes both portraits) "is evident. The connection can be traced even in the details of the treatment and technique. The separate touches of light on the gold-striped head-dress which fastens back the lady's beautiful dark hair, the variegated scarf thrown lightly round her waist, the folds of the sleeves, the hand with the finger-tips laid on the parapet: all these details might indicate the one master as well as the other."[90]

The transition from the Cobham Hall portrait to the "Lady" in the Crespi Collection is, to my mind, also a natural and proper one. The painter of the one is the painter of the other. Tradition is herein also perfectly consistent, and tradition has in each case a plausible signature to support it. The TITIANVS F. of the former portrait is paralleled by the T.V.—i.e. Titianus Vecellio, or Titianus Veneziano of the latter.[91] I have already dealt at some length with the question of the former signature, which appears to have been added actually during Titian's lifetime; in the present instance the letters appear almost, if not quite, coeval with the rest of the painting, and were undoubtedly intended for Titian's signature. The cases, therefore, are so far parallel, and the question naturally arises, Did Titian really have any hand in the painting of this portrait? Signor Venturi[92] strongly denies it; to him the T.V. matters nothing, and he boldly proclaims Licinio the author.

I confess the matter is not thus lightly to be disposed of; there is no valid reason to doubt the antiquity of the inscription, which, on the analogy of the Cobham Hall picture, may well have been added in Titian's own lifetime, and for the same reason that I there suggested—viz. that Titian had in some way or other a hand in the completion, or may be the alteration, of his deceased master's work.[93] For it is my certain conviction that the painter

of the Crespi "Lady" is none other than Giorgione himself.

Before, however, discussing the question of authorship, it is a matter of some moment to be able to identify the lady represented. An old tradition has it that this is Caterina Cornaro, and, in my judgment, this is perfectly correct.[94] Fortunately, we possess several well-authenticated likenesses of this celebrated daughter of the Republic. She had been married to the King of Cyprus, and after his death had relinquished her quasi-sovereign rights in favour of Venice. She then returned home (in 1489) and retired to Asolo near Castelfranco, where she passed a quiet country life, enjoying the society of the poets and artists of the day, and reputed for her kindliness and geniality. Her likeness is to be seen in three contemporary paintings:—

1. At Buda-Pesth, by Gentile Bellini, with inscription.

2. In the Venice Academy, also by Gentile Bellini, who introduces her and her attendant ladies kneeling in the foreground, to the left, in his well-known "Miracle of the True Cross," dated 1500.

3. In the Berlin Gallery, by Jacopo de' Barbari, where she appears kneeling in a composition of the "Madonna and Child and Saints."

MARBLE BUST OF CATERINA CORNAROPORTRAIT OF CATERINA CORNARO

Finally we see Caterina Cornaro in a bust in the Pourtalès Collection at Berlin, here reproduced,[95] seen full face, as in the Crespi portrait. I know not on what outside authority the identification rests in the case of the bust, but it certainly appears to represent the same lady as in the above-mentioned pictures, and is rightly accepted as such by modern German critics.[96]

To my eyes, we have the same lady in the Crespi portrait. Mr. Berenson, unaware of the identity, thus describes her:[97] "Une grande dame italienne est devant nous, éclatante de santé et de magnificence, énergique, débordante, pleine d'une chaude sympathie, source de vie et de joie pour tous ceux qui l'entourent, et cependant réfléchie, pénétrante, un peu ironique bien qu'indulgente."

Could a better description be given to fit the character of Caterina Cornaro, as she is known to us in history? How little likely, moreover, that tradition should have dubbed this homely person the ex-Queen of Cyprus

had it not been the truth!

Now, if my contention is correct, chronology determines a further point. Caterina died in 1510, so that this likeness of her (which is clearly taken from life) must have been done in or before the first decade of the sixteenth century.[98] This excludes Licinio and Schiavone (both of whom have been suggested as the artist), for the latter was not even born, and the former—whose earliest known picture is dated 1520—must have been far too young in 1510 to have already achieved so splendid a result. Palma is likewise excluded, so that we are driven to choose between Titian and Giorgione, the only two Venetian artists capable of such a masterpiece before 1510.

As to which of these two artists it is, opinions—so far as any have been published—are divided. Yet Dr. Gronau, who claims it for Titian, admits in the same breath that the hand is the same as that which painted the Cobham Hall picture and the Pitti "Concert," a judgment in which I fully concur. Dr. Bode[99] labels it "Art des Giorgione." Finally, Mr. Berenson, with rare insight proclaimed the conception and the spirit of the picture to be Giorgione's.[100] But he asserts that the execution is not fine enough to be the master's own, and would rank it—with the "Judith" at St. Petersburg—in the category of contemporary copies after lost originals. This view is apparently based on the dangerous maxim that where the execution of a picture is inferior to the conception, the work is presumably a copy. But two points must be borne in mind, the actual condition of the picture, and the character of the artist who painted it. Mr. Berenson has himself pointed out elsewhere[101] that Giorgione, "while always supreme in his conceptions, did not live long enough to acquire a perfection of draughtsmanship and chiaroscuro equally supreme, and that, consequently, there is not a single universally accepted work of his which is absolutely free from the reproaches of the academic pedant." Secondly, the surface of this portrait has lost its original glow through cleaning, and has suffered other damage, which actually debarred Crowe and Cavalcaselle (who saw the picture in 1877) from pronouncing definitely upon the authorship. The eyes and flesh, they say,[102] were daubed over, the hair was new, the colour modern. A good deal of this "restoration" has since been removed, but the present appearance of the panel bears witness to the harsh treatment suffered years ago. Nevertheless,

the original work is before us, and not a copy of a lost original, and Mr. Berenson's enthusiastic praise ought to be lavished on the actual picture as it must have appeared in all its freshness and purity. "Je n'hésiterais pas," he declares,[103] "à le proclamer le plus important des portraits du maître, un chef-d'oeuvre ne le cédant à aucun portrait d'aucun pays ou d'aucun temps."

And certainly Giorgione has created a masterpiece. The opulence of Rubens and the dignity of Titian are most happily combined with a delicacy and refinement such as Giorgione alone can impart. The intense grasp of character here displayed, the exquisite *intimité*, places this wonderful creation of his on the highest level of portraiture. There is far less of that moody abstraction which awakens our interest in most of his portraits, but much greater objective truth, arising from that perfect sympathy between artist and sitter, which is of the first importance in portrait-painting. History tells us of the friendly encouragement the young Castelfrancan received at the hands of this gracious lady, and he doubtless painted this likeness of her in her country home at Asolo, near to Castelfranco, and we may well imagine with what eagerness he acquitted himself of so flattering a commission. Vasari tells us that he saw a portrait of Caterina, Queen of Cyprus, painted by Giorgione from the life, in the possession of Messer Giovanni Cornaro. I believe that picture to be the very one we are now discussing.[104] The documents quoted by Signor Venturi[105] do not go back beyond 1640, so that it is, of course, impossible to prove the identity, but the expression "from the life" (as opposed to Titian's posthumous portrait of her) applies admirably to our likeness. What a contrast to the formal presentation of the queenly lady, crown and jewels and all, that Gentile Bellini has left us in his portrait of her now at Buda-Pesth!—and in that other picture of his where she is seen kneeling in royal robes, with her train of court ladies, as though attending a state function! How Giorgione has penetrated through all outward show, and revealed the charm of manner, the delightful *bonhomie* of his royal patroness!

We are enabled, by a simple calculation of dates, to fix approximately the period when this portrait was painted. Gentile Bellini's picture of "The Miracle of the True Cross" is dated 1500—that is, when Caterina Cornaro was forty-six years old (she was born in 1454). In Signor Crespi's picture she appears, if anything, younger in appearance, so that, at latest, Giorgione painted her portrait in 1500. Thus, again, we arrive at the same conclusion,

that the master distinguished himself very early in his career in the field of portraiture, and the similarity in style between this portrait and the Cobham Hall one is accounted for on chronological grounds. All things considered, it is very probable that this portrait was his earliest real success, and proved a passport to the favourable notice of the fashionable society of Venice, leading to the commission to paint the Doge, and the Gran Signori, who visited the capital in the year 1500. That Giorgione was capable of such an achievement before his twenty-fourth year constitutes, we may surely admit, his strongest right to the title of Genius.[106]

PORTRAIT OF A MAN

The Barberigo gentleman and the Caterina Cornaro are comparatively unfamiliar, owing to their seclusion in private galleries. Not so the third portrait, which hangs in the National Gallery, and which, in my opinion, should be included among Giorgione's authentic productions. This is No. 636, "Portrait of a Poet," attributed to Palma Vecchio; and the catalogue continues: "This portrait of an unknown personage was formerly ascribed to Titian, and supposed to represent Ariosto; it has long since been recognised as a fine work by Palma." I certainly do not know by whom this portrait was first recognised as such, but as the transformation was suddenly effected one day under the late Sir Frederic Burton's *regime*, it is natural to suppose he initiated it. No one to-day would be found, I suppose, to support the older view, and the rechristening certainly received the approval of Morelli;[107] modern critics apparently acquiesce without demur, so that it requires no little courage to dissent from so unanimous an opinion. I confess, therefore, it was no small satisfaction to me to find the question had been raised by an independent inquirer, Mr. Dickes, who published in the *Magazine of Art*, 1893, the results of his investigations, the conclusion at which he arrived being that this is the portrait of Prospero Colonna, Liberator of Italy, painted by Giorgione in the year 1500.

Briefly stated, the argument is as follows:—

I. [1] The person represented closely resembles Prospero Colonna (1464-1523), whose authentic likeness is to be seen—

(*a*) In an engraving in Pompilio Totti's
"Ritratti et Elogie di Capitani illustri.
Rome, 1635."

(*b*) In a bust in the Colonna Gallery, Rome.

(*c*) In an engraving in the "Columnensium
Procerum" of the Abbas Domenicus
de Santis. Rome, 1675.

 (All three are reproduced in the article in question.)
 [2] The description of Prospero Colonna, given
by Pompilio Totti (in the above book)
tallies with our portrait.

[3] The accessories in the picture confirm the
identity—e.g. the St Andrew's Cross, or
saltire, is on the Colonna family banner;
the bay, emblem of victory, is naturally
associated with a great captain; the rosary
may refer to the fact of Prospero's residence
as lay brother in the monastery of the
Olivetani, near Fondi, which was rebuilt
by him in 1500.

II. Admitting the identity of person, chronology
determines the probable date of the execution
of this portrait, for Prospero visited
Venice presumably in the train of Consalvo
Ferrante in 1500. He was then thirty-six
years of age.

III. Assuming this date to be correct, no other Venetian
artist but Giorgione was capable of producing

so fine and admittedly "Giorgionesque" a portrait at so early a date.

IV. Internal evidence points to Giorgione's authorship.

It will be seen that the logic employed is identical with that by which I have tried to establish the identity of Signor Crespi's picture. In the present case, I should like to insist on the fourth consideration rather than on the other points, iconographical or chronological, and see how far our portrait bears on its face the impress of Giorgione's own spirit.

The conception, to begin with, is characteristic of him—the pensive charm, the feeling of reserve, the touch of fanciful imagination in the decorative accessories, but, above all, the extreme refinement. All this very naturally fits the portrait of a poet, and at a time when it was customary to label every portrait with a celebrated name, what more appropriate than Ariosto, the court poet of Ferrara? But this dreamy reserve, this intensity of suppressed feeling is characteristic of all Giorgione's male portraits, and is nowhere more splendidly expressed than in this lovely figure. Where can the like be found in Palma, or even Titian? Titian is more virile in his conception, less lyrical, less fanciful, Palma infinitely less subtle in characterisation. Both are below the level of Giorgione in refinement; neither ever made of a portrait such a thing of sheer beauty as this. If this be Palma's work, it stands alone, not only far surpassing his usual productions in quality, but revealing him in a wholly new phase; it is a difference not of degree, but of kind.

Positive proofs of Giorgione's hand are found in the way the hair is rendered—that lovely dark auburn hair so often seen in his work,—in the radiant oval of the face, contrasting so finely with the shadows, which are treated exactly as in the Cobham picture, only that here the chiaroscuro is more masterly, in the delicate modelling of the features, the pose of the head, and in the superb colour of the whole. In short, there is not a stroke that does not reveal the great master, and no other, and it is incredible that modern criticism has not long ago united in recognising Giorgione's handiwork.[108]

The date suggested—1500—is also consistent with our own deductions as to Giorgione's rapid development, and the distinguished

character of his sitter—if it be Prospero Colonna—is quite in keeping with the vogue the artist was then enjoying, for it was in this very year, it will be remembered, that he painted the Doge Agostino Barberigo.

I therefore consider that Mr. Dickes' brilliant conjectures have much to support them, and, so far as the authorship is concerned, I unhesitatingly accept the view, which he was the first to express, that Giorgione, and no other, is the painter. Our National Collection therefore boasts, in my opinion, a masterpiece of his portraiture.

PORTRAIT OF A MAN (Unfinished)

If it were not that Morelli, Mr. Berenson and others have recognised in the "Portrait of a Gentleman," in the Querini-Stampalia Gallery in Venice, the same hand as in the National Gallery picture, one might well hesitate to claim it for Giorgione, so repainted is its present condition. I make bold, however, to include it in my list, and the more readily as Signor Venturi definitely assigns it to Giorgione himself, whose name, moreover, it has always borne. This unfinished portrait is, despite its repaint, extraordinarily attractive, the rich browns and reds forming a colour-scheme of great beauty. It cannot compare, however, in quality with our National Gallery highly-finished example, to which it is also inferior in beauty of conception. These two portraits illustrate the variableness of the painter; both were probably done about the same time—the one seemingly *con amore*, the other left unfinished, as though the artist or his sitter were dissatisfied. Certainly the cause could not have been Giorgione's death, for the style is obviously early, probably prior to 1500.

The view expressed by Morelli[109] that this may be a portrait of one of the Querini family, who were Palma's patrons, has nothing tangible to support it, once Palma's authorship is contested. But the unimaginative Palma was surely incapable of such things as this and the National Gallery portrait!

PORTRAIT OF A MANPORTRAIT OF A MAN

England boasts, I believe, yet another magnificent original Giorgione portrait, and one that is probably totally unfamiliar to connoisseurs. This is

the "Portrait of an Unknown Man," in the possession of the Hon. Mrs Meynell-Ingram at Temple Newsam in Yorkshire. A small and ill-executed print of it was published in the *Magazine of Art*, April 1893, where it was attributed to Titian. Its Giorgionesque character is apparent at first glance, and I venture to hope that all those who may be fortunate enough to study the original, as I have done, will recognise the touch of the great master himself. Its intense expression, its pathos, the distant look tinged with melancholy, remind us at once of the Buda-Pesth, the Borghese, and the (late) Casa Loschi pictures; its modelling vividly recalls the central figure of the Pitti "Concert," the painting of sleeve and gloves is like that in the National Gallery and Querini-Stampalia portraits just discussed. The general pose is most like that of the Borghese "Lady." The parapet, the wavy hair, the high cranium are all so many outward and visible signs of Giorgione's spirit, whilst none but he could have created such magnificent contrasts of colour, such effects of light and shade. This is indeed Giorgione, the great master, the magician who holds us all fascinated by his wondrous spell.

Last on the list of portraits which I am claiming as Giorgione's, and probably latest in date of execution, comes the splendid so-called "Physician Parma," in the Vienna Gallery. Crowe and Cavalcaselle thus describe it: "This masterly portrait is one of the noblest creations of its kind, finished with a delicacy quite surprising, and modelled with the finest insight into the modulations of the human flesh.... Notwithstanding, the touch and the treatment are utterly unlike Titian's, having none of his well-known freedom and none of his technical peculiarities. Yet if asked to name the artist capable of painting such a likeness, one is still at a loss. It is considered to be identical with the portrait mentioned by Ridolfi as that of 'Parma' in the collection of B. della Nave (Merav., i. 220); but this is not proved, nor is there any direct testimony to show that it is by Titian at all."[110]

Herr Wickhoff[111] goes a step further. He says: "Un autre portrait qui porte le nom de Titien est également l'une des oeuvres les plus remarquables du Musée. On prétend qu'il représente le 'Médecin du Titien, Parma'; mais c'est là une pure invention, imaginée par un ancien directeur du Musée, M. Rosa, et admise de confiance par ses successeurs. M. Rosa avait été amené à la concevoir par la lecture d'un passage de Ridolfi. Le costume suffirait à lui seul, pourtant, pour la démentir: c'est le costume officiel d'un sénateur

vénitien, et qui par suite ne saurait avoir été porté par un médecin. Le tableau est incontestablement de la même main que les deux 'Concerts' du Palais Pitti et du Louvre, qui portent tous deux le nom de Giorgione. Si l'on attribue ces deux tableaux au Giorgione, c'est à lui aussi qu'il faut attribuer le portrait de Vienne; si, comme feu Morelli, on attribue le tableau du Palais Pitti au Titien, il faut approuver l'attribution actuelle de notre portrait au même maître." I am glad that Herr Wickhoff recognises the same hand in all three works. I am sorry that in his opinion this should be Domenico Campagnola's. I have already referred to this opinion when discussing the Louvre "Concert," and must again emphatically dissent from this view. Campagnola, as I know him in his pictures and frescoes at Padua,—the only authenticated examples by which to judge him,[112] was utterly inadequate to such tasks. The grandeur and dignity of the Vienna portrait is worthy of Titian, whose virility Giorgione more nearly approaches here than anywhere else. But I agree with the verdict of Crowe and Cavalcaselle that his is not the hand that painted it, and believe that the author of the Temple Newsam "Man" also produced this portrait, probably a few years later, at the close of his career.

NOTES:

[85]

Or "points" (*punte*). The translation is that used by Blashfield and Hopkins, vol. iv. 260.

[86]

Assuming he was born in 1477, which is by no means certain.

[87]

Dr. Richter in the *Art Journal*, 1895, p. 90. Mr. Claude Phillips, in his *Earlier Work of Titian*, p. 58, note, objects that Vasari's "giubone di raso inargentato" is not the superbly luminous steel-grey sleeve of this "Ariosto," but surely a vest of satin embroidered with silver. I think we need not examine Vasari's casual descriptions quite so closely; "a doublet of silvered satin wherein the stitches could be counted" is fairly accurate. "Quilted sleeves" would no doubt be the tailor's term.

[88]

It is not quite clear whether the single letter is F or T.

[89]

A curious fact, which corroborates my view, is that the four old copies which exist are all ascribed to Giorgione (at Vicenza, Brescia, and two lately in English collections). See Crowe and Cavalcaselle, p. 201.

[90]

Gronau: *Tizian*, p. 21.

[91]

See, however, note on p. 133.

[92]

La Galleria Crespi.

[93]

The documents quoted by Signor Venturi show the signature was there in 1640.

[94]

When in the Martinengo Gallery at Brescia (1640) it bore this name. See Venturi, *op. cit.*, and Crowe and Cavalcaselle, *Titian*, ii. 58.

[95]

From *Das Museum*, No. 79. "*Unbekannter Meister um* 1500. *Bildnis der Caterina Cornaro.*" I am informed the original is now in the possession of the German Ambassador at The Hague, and that a plaster cast is at Berlin.

[96]

Dr. Bode (*Jahrbuch*, 1883, p. 144) says that Count Pourtalès acquired this bust at Asolo.

[97]

Gazette des Beaux Arts, 1897, pp. 278-9. Since (1901) republished in his *Study and Criticism of Italian Art*, vol. i. p. 85.

[98]

Titian's posthumous portrait of Caterina is lost. The best known copy is in the Uffizi. Crowe and Cavalcaselle long ago pointed out the absurdity of regarding this fancy portrait as a true likeness of the long deceased queen. It bears no resemblance whatever to the Buda-Pesth portrait, which is the latest of the group.

[99]

Cicerone, sixth edition.

[100]

Gazette des Beaux Arts, 1897, pp. 278-9.

[101]

Venetian Painting at the New Gallery, 1895, p. 41.

[102]

Titian, ii. 58.

[103]

Gazette des Beaux Arts, loc cit.

[104]

Life of Giorgione. The letters T.V. either were added after 1544, or Vasari did not interpret them as Titian's signature.

[105]

La Galleria Crespi, op. cit.

[106]

The importance of this portrait in the history of the Renaissance is discussed, *postea*, p. 113.

[107]

ii. 19.

[108]

This picture was transferred in 1857 from panel to canvas, but is otherwise in fine condition.

[109]

Morelli, ii. 19, note.

[110]

Crowe and Cavalcaselle: *Titian*, p. 425.

[111]

Gazette des Beaux Arts, 1893, p. 135.

[112]

It is customary to cite the Prague picture of 1525 as his work. The clumsy signature CAM was probably intended for Campi, the real author, and its genuineness is not above suspicion. It is a curious *quid pro quo*.

CHAPTER V

ADDITIONAL PICTURES OTHER THAN PORTRAITS

I have now pointed out six portraits which, in my opinion, should be included in the roll of genuine Giorgiones. No doubt others will, in time, be identified, but I leave this fascinating quest to pass to the consideration of other paintings illustrating a different phase of the master's art.[113]

We know that the romantic vein in Giorgione was particularly strong, that he naturally delighted in producing fanciful pictures where his poetic imagination could find full play; we have seen how the classic myth and the mediaeval romance afforded opportunities for him to indulge his fancy, and we have found him adapting themes derived from these sources to the decoration of *cassoni*, or marriage chests. Another typical example of this practice is afforded by his "Orpheus and Eurydice," in the gallery at Bergamo, a splendid little panel, probably, like the "Apollo and Daphne" in the Seminario at Venice, intended as a decorative piece of applied art. Although bearing Giorgione's name by tradition, modern critics have passed it by presumably on the ground that "it is not good enough,"—that fatal argument which has thrown dust in the eyes of the learned. As if the artist would naturally expend as much care on a trifle of this kind as on the Castelfranco altar-piece, or the Dresden "Venus"! Yet what greater beauty of conception, what more poetic fancy is there in the "Apollo and Daphne" (which is generally accepted as genuine) than in this little "Orpheus and Eurydice"? Nay, the execution, which is the point contested, appears to me every whit as brilliant, and in preservation the latter piece has the advantage. Not a touch but what can be paralleled in a dozen other works—the feathery trees against the luminous sky, the glow of the horizon, the splendid effects of light and shadow, the impressive grandeur of the wild scenery, the small figures in mid-distance, even the cast of drapery and shape of limbs are repeated elsewhere. Let anyone contrast the delicacy and the glow of this little panel with several similar productions of the Venetian school hanging in

the same gallery, and the gulf that separates Giorgione from his imitators will I think, be apparent.

ORPHEUS AND EURYDICE

In the same category must be ranked two very small panels in the Gallery at Padua (Nos. 42 and 43), attributed with a query to Giorgione. These are apparently fragments of some decorative series, of which the other parts are missing. The one represents "Leda and the Swan," the other a mythological subject, where a woman is seated holding a child, and a man also seated, holds flowers. The latter recalls one of the figures in the National Gallery "Epiphany." The charm of these fragments lies in the exquisite landscapes, which, in minuteness of finish and loving care, Giorgione has nowhere surpassed. The gallery at Padua is thus, in my opinion, the possessor of four genuine examples of Giorgione's skill as a decorator, for we have already mentioned the larger *cassone* pieces[114] (Nos. 416 and 417).

Of greater importance is the "Unknown Subject," in the National Gallery (No. 1173), a picture which, like so many others, has recently been taken from Giorgione, its author, and vaguely put down to his "School." But it is time to protest against such needless depreciation!

In spite of abrasion, in spite of the loss of glow, in spite of much that disfigures, nay disguises, the master's own touch, I feel confident that Giorgione and no other produced this beautiful picture.[115] Surely if this be only school work, we are vainly seeking a mythical master, an ideal who never could have existed. What more dainty figures, what more delicate hues, what more exquisite feeling could one look for than is here to be found? True, the landscape has been renovated, true, the Giorgionesque depth and richness is gone, the mellow glow of the "Epiphany," which hangs just below, is sadly wanting, but who can deny the charm of the picturesque scenery, which vividly recalls the landscape backgrounds elsewhere in the master's own work, who can fail to admire the natural and unstudied grouping of the figures, the artlessness of the whole, the loving simplicity with which the painter has done his work? All is spontaneous; the spirit is not that of a laborious imitator, painfully seeking "effects" from another's inspiration; sincerity and naïveté are too apparent for this to be the work of any but a

quite young artist, and one whose style is so thoroughly "Giorgionesque" as to be none other than the young Giorgione himself. In my opinion this is one of his earliest essays into the region of romance, painted probably before his twenty-first year, betraying, like the little legendary pictures in the Uffizi, a strong affinity with Carpaccio.[116]

? THE GOLDEN AGE

As to the subject many conjectures have been made: Aristotle surrounded by emblems illustrating the objects with which his philosophy was concerned, an initiation into some mystic rite, the poet musing in sadness on the mysteries of life, the philosopher imparting wisdom to the young, etc. etc. I believe Giorgione is simply giving us a poetical rendering of "The Golden Age," where, like Plato's philosopher-king, the seer all-wise and all-powerful holds sway, before whom the arts and sciences do homage; in this earthly
paradise even strange animals live in happy harmony, and all is peace. Such a theme would well have suited Giorgione's temperament, and Ridolfi actually tells us that this very subject was taken by Giorgione from the pages of Ovid, and adapted by him to his own ends.[117] But whether this represents "The Golden Age," or some other allegory or classic story, the picture is completely characteristic of all that is most individual in Giorgione, and I earnestly hope the slur now cast upon its character by the misleading label will be speedily removed.[118] For the public believes more in the labels it reads, than the pictures it sees.

Finally, in the "Venus disarming Cupid," of the Wallace collection, we have, in my opinion, the wreck of a once splendid Giorgione. In the recent re-arrangement of the Gallery, this picture, which used to hang in an upstairs room, and was practically unknown, has been hung prominently on the line, so that its beauties, and, alas! its defects, can be plainly seen. The outlines are often distorted and blurred, the Cupid has become monstrous, the delicacy of the whole effaced by ill-usage and neglect. Yet the splendour of colour, the cast of drapery, the flow of line, proclaims the great master himself. There is no room, moreover, for such a mythical compromise as that which is proposed by the catalogue, "It stands midway in style between Giorgione and

Titian in his Giorgionesque phase." No better instance could be adduced of the fallacy of perfection implied in the minds of most critics at the mention of Giorgione's name; yet if we accept the Louvre "Concert," if we accept the Hermitage "Judith," why dispute Giorgione's claim on the ground of "weakness of construction"? This "Venus and Cupid" is vastly inferior in quality to the Dresden "Venus,"—let us frankly admit it,—but it is none the less characteristic of the artist, who must not be judged by the standard of his exceptional creations, but by that of his normal productions.[119]

VENUS AND ADONIS

Just such another instance of average merit is afforded by the "Venus and Adonis" of the National Gallery (No. 1123), from which, had not an artificial standard of excellence been falsely raised, Giorgione's name would never have been removed. I am happily not the first to call attention to the propriety of the old attribution, for Sir Edward Poynter claims that the same hand that produced the Louvre "Concert" is also responsible for the "Venus and Adonis."[120] I fully share this opinion. The figures, with their compactly built and rounded limbs, are such as Giorgione loved to model, the sweep of draperies and the splendid line indicate a consummate master, the idyllic landscape framing episodes from the life of Adonis is just such as we see in the Louvre picture and elsewhere, the glow and splendour of the whole reveal a master of tone and colouring. Some good judges would give the work to the young Titian, but it appears too intimately "Giorgionesque" to be his, although I admit the extreme difficulty in drawing the line of division. Passages in the "Sacred and Profane Love" of the Borghese Gallery are curiously recalled, but the National Gallery picture is clearly the work of a mature and experienced hand, and not of any young artist. In my opinion it dates from about 1508, and illustrates the later phase of Giorgione's art as admirably as do the "Epiphany" (No. 1160) and the "Golden Age" (No. 1173) his earliest style. Between these extremes fall the "Portrait" (No. 636), and the "S. Liberale" (No. 269), the National Gallery thus affording unrivalled opportunity for studying the varying phases of the great Venetian master at different stages of his career.

We may now pass from the realm of "fancy" subjects to that of

sacred art—that is, to the consideration of the "Madonnas," "Holy Families," and "Santa Conversazione" pictures, other than those already described. The Beaumont "Adoration of the Shepherds," with its variant at Vienna, the National Gallery "Epiphany," the Madrid "Madonna with S. Anthony and S. Roch," and the Castelfranco altar-piece are the only instances so far of Giorgione's sacred art, yet Vasari tells us that the master "in his youth painted very many beautiful pictures of the Virgin."

This statement is on the face of it likely enough, for although the young Castelfrancan early showed his independence of tradition and his preference for the more modern phases of Bellini's art, it is extremely probable he was also called upon to paint some smaller devotional pieces, such, for instance, as "The Christ bearing the Cross," lately in the Casa Loschi at Vicenza.[121] It is noteworthy, all the same, that scarcely any "Madonna" picture exists to which his name still attaches, and only one "Holy Family," so far as I am aware, is credibly reputed to be his work. This is Mr. Benson's little picture, in all respects a worthy companion to the Beaumont and National Gallery examples. There is even a purer ring about this lovely little "Holy Family," a child-like sincerity and a simplicity which is very touching, while for sheer beauty of colour it is more enjoyable than either of the others. It may not have the depth of tone and mastery of chiaroscuro which make the Beaumont "Adoration" so subtly attractive, but in tenderness of feeling and daintiness of treatment it is not surpassed by any other of Giorgione's works. In its obvious defects, too, it is as thoroughly characteristic; it is needless to repeat here what I said when discussing the Beaumont and Vienna "Adoration"; the reader who compares the reproductions will readily see the same features in both works. Mr. Benson's little picture has this additional interest, that more than either of its companion pieces it points forward to the Castelfranco "Madonna" in the bold sweep of the draperies, the play of light on horizontal surfaces, and the exquisite gaiety of its colour.

THE "GIPSY" MADONNA

In claiming this picture for Giorgione I am claiming nothing new, for his name, in spite of modern critics, has here persistently survived. Not so

with a group of three Madonnas, one of which has for at least two centuries borne Titian's name, another which passes also for a work of the same painter, whilst the third was claimed by Crowe and Cavalcaselle again for Titian, partly on the analogy of the first-mentioned one.[122] The first is the so-called "Gipsy Madonna" in the Vienna Gallery, the second is a "Madonna" in the Bergamo Gallery, and the third is a "Madonna" again in Mr. Benson's collection.

I am happily not the first to identify the "Gipsy Madonna" as Giorgione's work, for it requires no little courage to tilt at what has been unquestioningly accepted as "the earliest known Madonna of Titian." I am indebted, therefore, to Signor Venturi for the lead,[123] although I have the satisfaction of feeling that independent study of my own had already brought me to the same conclusion.

Of course, all modern writers have recognised the "Giorgionesque" elements in this supposed Titian. "In the depth, strength, and richness of the colour-chord, in the atmospheric spaciousness and charm of the landscape background, in the breadth of the draperies, it is already," says Mr. Claude Phillips,[124] "Giorgionesque." Yet, he goes on, the Child is unlike Giorgione's type in the Castelfranco and Madrid pictures, and the Virgin has a less spiritualised nature than Giorgione's Madonnas in the same two pictures. On the other hand, Dr. Gronau, Titian's latest biographer, declares[125] that the thoughtful expression ("der tief empfundene Ausdruck") of the Madonna is essentially Giorgionesque. Morelli, with peculiar insight, protested against its being considered a very *early* work of Titian, basing his protest on the advanced nature of the landscape, which, he says,[126] "must have been painted six or eight years later than the end of the fifteenth century." But even he fell into line with Crowe and Cavalcaselle in ascribing the picture to Titian, failing to see that all difficulties of chronology and discrepancies of judgment between himself and the older historians could be reconciled on the hypothesis of Giorgione's authorship. For Giorgione, as Morelli rightly saw, developed far more rapidly than Titian, so that a Titian landscape of, say, 1506-8 (if any such exist!) would correspond with one by Giorgione of, say, 1500. I agree with Crowe and Cavalcaselle and those writers who date back the "Gipsy Madonna" to the end of the fifteenth century, but I must emphatically support Signor Venturi in his claim that Giorgione is the author.

Before, however, looking at internal evidence to prove this contention, we may note that another example of the same composition exists in the Gallery of Rovigo, identical save for a cartellino on which is inscribed TITIANVS. To Crowe and Cavalcaselle this was evidence to confirm Titian's claim to be the painter of what they considered the original work—viz. the Vienna picture, of which the Rovigo example was, in their opinion, a later copy. A careful examination, however, of the latter picture has convinced me that they were curiously right and curiously wrong. That the Rovigo work is posterior to the Vienna one is, I think, patent to anyone conversant with Venetian painting, but why should the one bear Titian's name on an apparently authentic cartellino, and not the other? The simple and straightforward explanation appears the best—viz. that the Rovigo picture is actually by Titian, who has taken the Vienna picture (which I attribute to Giorgione) as his model and directly repeated it. The qualities of the work are admirable, and worthy of Titian, and I venture to think this "Madonna" would long ago have taken its rightful place among the pictures of the master had it not hung in a remote provincial gallery little visited by travellers, and in such a dark corner as to escape detection. The form TITIANVS points to a period after 1520,[127] when Giorgione had been some years dead, so that it was not unnatural that in after times the credit of invention rested with the author of the signed picture, and that his name came gradually to be attached also to the earlier example. The engraving of Meyssen (*circa* 1640) thus bears Titian's name, and both engraving and the repetition at Rovigo are now adduced as evidence of Titian's authorship of the Vienna "Gipsy Madonna."

But is there any proof that Titian ever copied or repeated any other work of Giorgione? There is, fortunately, one great and acknowledged precedent, the "Venus" in the Tribune of the Uffizi, which is *directly* taken from Giorgione's Dresden "Venus," The accessories, it is true, are different, but the nude figures are line for line identical.[128] Other painters, Palma, Cariarli, and Titian, elsewhere, derived inspiration from Giorgione's prototype, but Titian actually repeats the very figure in this "Venus"; so that there is nothing improbable in my contention that Titian also repeated Giorgione's "Gipsy Madonna," adding his signature thereto, to the confusion and confounding of later generations.

MADONNA AND CHILD

It is worthy of note that not a single "Madonna and Child" by Titian exists, except the little picture in Mr. Mond's collection, painted quite in the artist's old age. Titian invariably paints "Madonna and Saints," or a "Holy Family," so that the three Madonna pictures I am claiming for Giorgione are marked off by this peculiarity from the bulk of Titian's work. This in itself is not enough to disqualify Titian, but it is a factor in that cumulative proof by which I hope Giorgione's claim may be sustained. The marble parapet again is a feature in Giorgione's work, but not in Titian's. But the most convincing evidence to those who know the master lies in the composition, which forms an almost equilateral triangle, revealing Giorgione's supreme sense of beauty in line. The splendid curves made by the drapery, the pose of the Child, so as to obtain the same unbroken sweep of line, reveals the painter of the Dresden "Venus." The painting of the Child's hand over the Madonna's is precisely as in the Madrid picture, where, moreover, the pose of the Child is singularly alike. The folds of drapery on the sleeve recur in the same picture, the landscape with the small figure seated beneath the tree is such as can be found in any Giorgione background. The oval of the face and the delicacy of the features are thoroughly characteristic, as is the spirit of calm reverie and tender simplicity which Giorgione has breathed into his figures.

The second and third Madonna pictures—viz. the one at Bergamo, and its counterpart in Mr. Benson's collection—appear to be somewhat later in date of execution, but reveal many points in common with the "Gipsy Madonna." The beauty of line is here equally conspicuous; the way the drapery is carried out beyond the elbow so as to form one long unbroken curve, the triangular composition, the marble parapet, are so many proofs of Giorgione's hand. Moreover, we find in Mr. Benson's picture the characteristic tree-trunks, so suggestive of solemn grandeur,[129] and the striped scarf,[130] so cunningly disposed to give more flowing line and break the stiffness of contour.

The Bergamo picture closely resembles Mr. Benson's "Madonna," from which, indeed, it varies chiefly in the pose of the Child (whose left leg here sticks straight out), whilst the landscape is seen on the left side, and

there are no tree-trunks. I cannot find that any writer has made allusion to this little gem, which hangs high up on the end wall of the Lochis section of the gallery (No. 232); I hope others will examine this new-found work at a less inconvenient height, as I have done, and that their opinion will coincide with mine that the same hand painted the Benson "Madonna," and that that hand is Giorgione's.

Before quitting the subject of the "Madonna and Child," another example may be alluded to, about which it would be unwise to express any decided opinion founded only on a study of the photograph. This is a picture at St. Petersburg, to which Mr. Claude Phillips first directed attention,[131] stating his then belief that it might be a genuine Giorgione. After a recent visit to St. Petersburg, however, he has seen fit to register it as a probable copy after a lost original by the master, on the ground that "it is not fine enough in execution."[132] This, as I have often pointed out, is a dangerous test to apply in Giorgione's case, and so the authenticity of this "Madonna" may still be left an open question.

Finally, in the category of Sacred Art come two well-known pictures, both in public galleries, and both accredited to Giorgione. The first is the "Christ and the Adulteress" of the Glasgow Gallery, the second the "Madonna and Saints" of the Louvre. Many diverse opinions are held about the Glasgow picture; some ascribe it to Cariani, others to Campagnola. It is asserted by some that the same hand painted the Kingston Lacy "Judgment of Solomon," but that it is not the hand of Giorgione, and finally—to come to the view which I believe is the correct one—Dr. Bode and Sir Walter Armstrong[133] both believe that Giorgione is the painter.

THE ADULTERESS BEFORE CHRIST

The whole difficulty, as it seems to me, arises from the deep-rooted misapprehension in the minds of most critics of the character of Giorgione's art. In their eyes, he is something so perfect as to be incapable of producing anything short of the ideal. He could never have drawn so badly, he never could have composed so awkwardly, he never could have been so inexpressive!—such is the usual criticism. I have elsewhere insisted upon the unevenness which invariably characterises the productions of men who are gifted with a strong artistic temperament, and in Giorgione's case, as I

believe, this is particularly true. The Glasgow picture is but one instance of many where, if correctness of drawing, perfection of composition, and inevitableness of expression are taken as final tests, the verdict must go against the painter. He either failed in these cases to come up to the standard reached elsewhere, or he is not the painter. Modern negative criticism generally adopts the latter solution, with the result that not a score of pictures pass muster, and the virtues of these chosen few are so extolled as to make it all but impossible to see the reverse of the medal. But those who accept the "Judith" at St. Petersburg, the Louvre "Concert," the Beaumont "Adoration of the Shepherds" (to name only three examples where the drawing is strange), cannot consistently object to admit the Glasgow "Christ and the Adulteress" into the fold. Nay, if gorgeousness of colour, splendour of glow, mastery of chiaroscuro, and brilliancy of technique are qualities which go to make up great painting, then the Glasgow picture must take high rank, even in a school where such qualities found their grandest expression.

Comparisons of detail may be noted, such as the resemblance in posture and type of the Accuser with the S. Roch of the Madrid picture, the figure of the Adulteress with that of the False Mother in the Kingston Lacy picture, the pointing forefingers, the typical landscape, the cast of the draperies, details which the reader can find often repeated elsewhere. But it is in the treatment of the subject that the most characteristic features are revealed. The artist was required—we know not why—to paint this dramatic scene; he had to produce a "set piece," where action and graphic representation was urgently needed. How little to his taste! How uncongenial the task! The case is exactly paralleled by the "Judgment of Solomon," the only other dramatic episode Giorgione appears to have attempted, and the result in each case is the same—no real dramatic unity, but an accidental arrangement of the figures, with rhetorical action. The want of repose in the Christ offends, the stageyness of the whole repels. How different when Giorgione worked *con amore*! For it seems this composition gave him much trouble. Of this we have a most interesting proof in an almost contemporary Venetian version of the same subject, where the scheme has been recast. This picture belongs to Sir Charles Turner, in London, and, so far as intelligibleness of composition goes, may be said to be an improvement on the Glasgow version. It is highly probable that this painting derives from

some alternative drawing for the original picture. That the Glasgow version acquired some celebrity we have further proof in an almost exact copy (with one more figure added on the right), which hangs in the Bergamo Gallery under Cariani's name, a painting which, in all respects, is utterly inferior to the original.[134]

The "Christ and the Adulteress," then, becomes for us a revelation of the painter's nature, of his methods and aims; but, with all its technical excellences, shall we not also frankly recognise the limitations of his art?[135]

MADONNA AND SAINTS

The "Madonna and Saints" of the Louvre, which persistently bears Giorgione's name, in spite of modern negative criticism, is marked by a lurid splendour of colour and a certain rough grandeur of expression, well calculated to jar with any preconceived notion of Giorgionesque sobriety or reserve. Yet here, if anywhere, we get that *fuoco Giorgionesco* of which Vasari speaks, that intensity of feeling, rendered with a vivacity and power to which the artist could only have attained in his latest days. In this splendid group there is a masculine energy, a fulness of life, and a grandeur of representation which carries *le grand style* to its furthest limits, and if Giorgione actually completed the picture before his death, he anticipated the full splendour of the riper Renaissance. To him is certainly due the general composition, with its superb lines, its beautiful curves, its majestic and dignified postures, its charming sunset background, to him is certainly due the splendid chiaroscuro and magic colour-chord; but it becomes a question whether some of the detail was not actually finished by Giorgione's pupil, Sebastiano del Piombo.[136] The drawing, for instance, of the hands vividly suggests his help, the type of S. Joseph in the background reminds us of the figure of S. Chrysostom in Sebastiano's Venice altar-piece, while the S. Catherine recalls the Angel in Sebastiano's "Holy Family" at Naples. If this be the case, we here have another instance of the pupil finishing his master's work, and this time probably after his death, for, as already pointed out, the "Evander and Aeneas" (at Vienna) must have been left by Giorgione well-nigh complete at an earlier stage than the year of his death.

That Sebastiano stood in close relation to his master, Giorgione, is

evidenced not only by Vasari's statement, but by the obvious dependence of the S. Giovanni Crisostomo altar-piece at Venice on Giorgionesque models. Moreover, the "Violin Player," formerly in the Sciarra Palace, at once reminds us of the "Barberigo" portrait at Cobham, while the "Herodias with the Head of John Baptist," dated 1510, now in the collection of Mr. George Salting, shows conclusively how closely related were the two painters in the last year of Giorgione's life. Sebastiano was twenty-five years of age in 1510, and appears to have worked under Giorgione for some time before removing to Rome, which he did on, or shortly before, his master's death. His departure left Titian, his associate under Giorgione, master of the field; he, too, had a hand in finishing some of the work left incomplete in the atelier, and his privilege it became to continue the Giorgionesque tradition, and to realise in utmost perfection in after years the aspirations and ideals so brilliantly anticipated by the young genius of Castelfranco.[137]

NOTES:

[113]

The Doges Agostino Barberigo, and Leonardo Loredano, Consalvo of Cordova, Giovanni Borgherini and his tutor, Luigi Crasso, and others, are mentioned as having sat to Giorgione for their portraits. Modern criticism has recently distributed several "Giorgionesque" portraits in English collections among Licinio, Lotto, and even Polidoro! But this disintegrating process may be, and has been, carried too far.

[114]

Two more small works may be mentioned which may tentatively be ascribed to Giorgione. "The Two Musicians," in the Glasgow Gallery (recently transferred to Campagnola), and a "Sta. Justina" (known to me only from a photograph), which has passed lately into the collection of Herr von Kauffmann at Berlin.

Signor Venturi (*L'Arte*, 1900) has just acquired for the National Gallery in Rome a "St. George slaying the Dragon." Judging only from the photograph, I should say he is correct in his identification of this as Giorgione's work. It seems to be akin to the "Apollo and Daphne," and "Orpheus and Eurydice."

[115]

I am pleased to find Signor Venturi has anticipated my own conclusion in his recently published *La Galleria Crespi*.

[116]

Mr. Cosmo Monkhouse (*In the National Gallery*, p. 223) has already rightly recognised the same hand in this picture and in the "Epiphany" hanging just below.

[117]

Meravig, i. 124.

[118]

By a happy accident the new "Giorgione" label, intended for the "Epiphany," No. 1160, was for some time affixed to No. 1173.

[119]

When in the Orleans Gallery the picture was engraved under Giorgione's name by de Longueil and Halbon.

[120]

New illustrated edition of the National Gallery Catalogue, 1900.

[121]

Now in America, in Mrs. Gardner's Collection.

[122]

Crowe and Cavalcaselle: *Titian*, i. p. III. This picture was then at Burleigh House.

[123]

See *La Galleria Crespi*, 1900.

[124]

The Earlier Work of Titian p. 24. *Portfolio*, October 1897.

[125]

Tizian, p. 16.

[126]

Morelli, ii. 57, note.

[127]

See *antea*, p. 71.

[128]

With the exception of the right arm, which Titian has let fall, instead placing it behind the head of the sleeping goddess. The effect of the beautiful curve is thereby lost, and Titian shows himself Giorgione's inferior in quality

of line.

[129]

As in the "Aeneas and Evander" (Vienna), the "Judith" (St Petersburg), the Madrid "Madonna and Saints," etc.

[130]

As in the "Caterina Cornare" of the Crespi collection at Milan.

[131]

Magazine of Art. July 1895.

[132]

North American Review. October 1899.

[133]

Magazine of Art, 1890, pp. 91 and 138.

[134]

The small divergencies of detail in the dress of the "Adulteress," etc. are just such as an imitator might have ventured to make. The hand and arm of the Christ have, however, been altered for the better.

[135]

This is the first time in Venetian art that the subject appears. It is frequently found later.

[136]

Cariani is by some made responsible for the whole picture. A comparison with an authentic example hanging (in the new arrangement of the Long Gallery), close by, ought surely to convince the advocates of Cariani of their mistake.

[137]

Morto da Feltre is mentioned by Vasari as having assisted Giorgione in the decoration of the Fondaco de' Tedeschi. This was in 1508. Otherwise, we know of no pupils or assistants employed by the master, a fact which goes to show that his influence was felt, not so much through any personal teaching, as through his work.

CHAPTER VI

GIORGIONE'S ART, AND PLACE IN HISTORY

The examination in detail of all those pictures best entitled, on internal evidence, to rank as genuine productions of Giorgione has incidentally revealed to us much that is characteristic of the man himself. We started with the axiom that a man's work is his best autobiography, and where, as in Giorgione's case, so little historical or documentary record exists, such indications of character as may be gleaned from a study of his life's work become of the utmost value. *Le style c'est l'homme* is a saying eminently applicable in cases where, as with Giorgione, the personal element is strongly marked. The subject, as we have seen over and over again, is so highly charged with the artist's mood, with his individual feelings and emotions, that it becomes unrecognisable as mere illustration, and the work passes by virtue of sheer inspiration into the higher realms of creative art. Such fusion of personality and subject is the characteristic of lyrical art, and in this domain Giorgione is a supreme master. His genius, as Morelli rightly pointed out, is essentially lyrical in contradistinction to Titian's, which is essentially dramatic. Take the epithets that we have constantly applied to his pictures in the course of our survey, and see how they bear out this statement—epithets such as romantic, fantastic, picturesque, gay, or again, delicate, refined, sensitive, serene, and the like; these bear witness to qualities of mind where the keynote is invariably exquisite feeling. Giorgione was, in fact, what is commonly called a poet-painter, gifted with the artistic temperament to an extraordinary degree, essentially impulsive, a man of moods. It is inevitable that such a man produces work of varying merit; inequality must be a characteristic feature of his art. In less fortunate circumstances than those in which Giorgione was placed, such temperaments as his become peevish, morose, morbid; but his lines were cast in pleasant places, and his moods were healthy, joyous, and serene. He does not concern himself with the tragedy of life, with its pathos

or its disappointments. In his two renderings of "Christ bearing the Cross"[138] the only instances we have of his portrayal of the Man of Sorrows—he appeals more to our sense of the dignity of humanity, and to the nobility of the Christ, than to our tenderer sympathies. How different from the pathetic Pietàs of his master, Giambellini! This shrinking from pain and sorrow, this dislike to the representation of suffering is, however, as much due to the natural gaiety and elasticity of youth as to the happy accident of his surroundings. We must never forget that Giorgione's whole achievement was over at an age when some men's life-work has hardly begun. The eighteen years of his activity were what we sometimes call the years of promise, and he must not be judged as we judge a Titian or a Michel Angelo. He is the wonderful youth, full of joyous aspirations, gilding all he touches with the radiance of his spirit. His pictures, suffused with a golden glow, are the reflection of his sunny life; the vividness and intensity of his passion are expressed in the gorgeousness of his colours.

I have elsewhere dwelt upon the precocity of Giorgione's talent, with its accompanying qualities of versatility, inequality, and productiveness, and I have pointed out the analogous phenomena in music and poetry. Giorgione, Schubert, and Keats are alike in temperament and quality of expression. They are curiously alike in the shortness of their lives,[139] and the fever-heat of their production. But they are strangely distinct in the manner of their lives. The disparity of outward circumstances accounts for the healthy tone of Giorgione's art, when contrasted with the morbid utterances of Keats. Schubert suffered privations and poverty, and his song was wrung from him alike at moments of inspiration and of necessity. But Giorgione is all aglow with natural energy; he suffered no restraints, nor is his art forced or morbid. Confine his spirit, check the play of his fancy, set him a task prescribed by convention or hampered by conditions, and you get proof of the fretfulness, the impatience of restraint which the artist felt. The "Judgment of Solomon" and "The Adulteress before Christ," the only two "set" pieces he ever attempted, eloquently show how he fell short when struggling athwart his genius. For to register a fact was utterly foreign to his nature; he records an impression, frankly surrendering his spirit to the sense of joy and beauty. He is not seldom incoherent, and may even grow careless, but in power of imagination and exuberance of fancy he is always supreme.

In one respect, however, Giorgione shows himself a greater than Schubert or Keats. He has a profounder insight into human nature in its varying aspects than either the musician or the poet. He is less a visionary, because his experience of men and things is greater than theirs; his outlook is wider, he is less self-centred. This power of grasping objective truth naturally shows itself most readily in the portraits he painted, and it was due to the force of circumstances, as I believe, that this faculty was trained and developed. Had Giorgione lived aloof from the world, had not his natural reticence and sensitiveness been dominated by outside influences, he might have remained all his life dreaming dreams, and seeing visions, a lyric poet indeed, but not a great and living, influence in his generation. Yet such undoubtedly he was, for he effected nothing short of a revolution in the contemporary art of Venice. Can the same be said of Schubert or Keats? The truth is that Giorgione had opportunities of studying human nature such as the others never enjoyed; fortune smiled upon him in his earliest years, and he found himself thrust into the society of the great, who were eager to sit to him for their portraits. How the young Castelfrancan first achieved such distinction is not told us by the historians, but I have ventured to connect his start in life with the presence of the ex-Queen of Cyprus, Caterina Cornaro, at Asolo, near Castelfranco; I think it more than probable that her patronage and recommendation launched the young painter on his successful career in Venice. Certain it is that he painted her portrait in his earlier days, and if, as I have sought to prove, Signor Crespi's picture is the long-lost portrait of the great lady, we may well understand the instant success such an achievement won.

 Here, if anywhere, we get Giorgione's great interpretative qualities, his penetration into human nature, his reading of character. It is an astonishing thing for one so young to have done, explicable psychologically on the existence of a lively sympathy between the great lady and the poet-painter. Had we other portraits of the fair sex by Giorgione, I venture to think we should find in them his reading of the human soul even more plainly evidenced than in the male portraits we actually possess.[140] For it is clear that the artist was "impressionable," and he would have given us more sympathetic interpretations of the fair sex than those which Titian has left us. The so-called "Portrait of the Physician Parma" (at Vienna) is another

instance of Giorgione's grasp of character, the virility and suppressed energy being admirably seized, the conception approaching more nearly to Titian's in its essential dignity than is usually the case with Giorgione's portraits. It is a matter of more regret, therefore, that the likenesses of the Doges Agostino Barberigo and Leonardo Loredano are missing, for in them we might have had specimens of work comparable to the Caterina Cornaro, which, in my opinion at all events, is Giorgione's masterpiece of portraiture.

I have given reasons elsewhere for dating this portrait at latest 1500. It is probably anterior by a few years to the close of the century. This deduction, if correct, has far-reaching consequences: it becomes actually the first *modern* portrait ever painted, for it is the earliest instance of a portrait instinct with the newer life of the Renaissance. And this brings us to the question: What was Giorgione's relation to that great awakening of the human spirit which we call the Renaissance? Mr. Berenson answers the question thus: "His pictures are the perfect reflex of the Renaissance at its height."[141] If this be taken to mean that Giorgione *anticipated* the aspirations and ideals of the riper Renaissance, I think we may acquiesce in the phrase; but that the onward movement of this great revival coincided only with the artist's years, and culminated at his death, is not historically correct. The wave had not reached its highest point by the year 1510, and Titian was yet to rise to a fuller and grander expression of the human soul. But Giorgione may rightly be called the Herald of the Renaissance, not only by virtue of the position he holds in Venetian painting, but by priority of appearance on the wider horizon of Italian Art.

Let us take the four great representative exponents of Italian Art at its best, Raphael, Correggio, Leonardo, and Michel Angelo. Chronologically, Giorgione precedes Raphael and Correggio, though Leonardo and Michel Angelo were born before him.[142] But had either of the latter proclaimed a new order of things as early as 1495? Michel Angelo was just twenty years old, and he had not yet carved his "Pietà" for S. Peter's. Leonardo, a man of forty-three, had not completed his "Cenacolo," and the "Mona Lisa" would not be created for another five or six years. Giorgione's "Caterina Cornaro," therefore, becomes the first masterpiece of the earlier Renaissance, and proclaims a revolution in the history of portraiture. In Venice itself we have only to look at the contemporary portraits by Alvise Vivarini and Gentile

Bellini, and at the slightly earlier busts by Antonello da Messina, to see what a world of difference in feeling and interpretation there is between them and Giorgione's portraits. What a splendid array of artistic triumphs must have sprung up around this masterpiece! The Cobham portrait and the National Gallery "Poet" are alone left us in much of their pristine splendour, but what of the lost portraits of the great Consalvo and of the Doge Agostino Barberigo, both of which must date from the year 1500?

Giorgione is then the Herald of the Renaissance, and never did genius arise in more fitting season. It was the right psychological moment for such a man, and Giorgione "painted pictures so perfectly in touch with the ripened spirit of the Renaissance that they met with the success which those things only find that at the same moment wake us to the full sense of a need and satisfy it."[143] This is the secret of his overwhelming influence on succeeding painters in Venice,—not, indeed, on his direct pupil Sebastiano del Piombo, and on his friend and associate Titian (who may fairly be called his pupil), but on such different natures as Lotto, Palma, Bonifazio, Bordone, Pordenone, Cariani, Romanino, Dosso Dossi, and a host of smaller men. The School of Giorgione numbers far more adherents than even the School of Leonardo, or the School of Raphael, not because of any direct teaching of the master, but because the "Giorgionesque" spirit was abroad, and the taste of the day required paintings like Giorgione's to satisfy it. But as no revolution can be effected without a struggle, and as there are invariably people opposed to any reform, whether in art or in anything else, we need not be surprised to find the academic faction, represented by the aged Giambellini and his pupils, resisting the progress of the Newer Art. In Giorgione's own lifetime, the exact measure of the opposition is not easy to gauge, but it bore fruit a few years later in the machinations of the official Bellinesque party to keep Titian out of the Ducal Palace when he was seeking State recognition,[144] Nevertheless, Giambellini, even at his age, found it advisable to modulate into the newer key, as may be seen in his "S. Giovanni Crisostomo enthroned," where not only is the conception lyrical and the treatment romantic, but the actual composition is on the lines of the essentially Giorgionesque equilateral triangle. This great altar-piece was painted three years after Giorgione's death, and no more splendid testimonial to the young painter's genius could be found than in the forced homage thus paid to his

memory by the octogenarian Giambellini.[145]

We have already, in the course of our survey of Giorgione's pictures noted the points wherein he was an initiator. "Genre subjects," and "Landscape with figures," as we should say nowadays, found in him their earliest exponent. Before him artists had, indeed, painted figures with a landscape background, but the perfect blend of Nature and human nature was his achievement. This was accomplished by artistic means of the simplest, yet irresistibly subtle in their appeal. The quality of line and the sensuousness of colour nowhere cast their spells over us more strangely than in Giorgione's pictures, and by these means he wrought "effects" such as no artist has surpassed. In these purely pictorial qualities he is supreme, and claims place with the few quintessential artists of the world; to him may be applied by analogy the phrase that Liszt applied to Schubert, "Le musicien le plus poète que jamais."

As an instrument of expression, then, colour is used by Giorgione more naturally and effectively than it is by any of the Venetian painters. It appeals directly to our senses, like rare old stained glass, and seems to be of the very essence of the object itself. An engraving or photograph after such a picture as the Louvre "Pastoral Symphony" fails utterly to convey the sense of exhilaration one feels in presence of the actual painting, simply because the tonic effect of the colour is wholly wanting. The golden shimmer of light, the vibration of the air, the saturation of atmosphere with pure colour are not only ingredients in, but are of the very essence of the creation. It has been well said that almost literally the chief colour on Giorgione's palette was sunlight.[146] His masterly treatment of light and shadow, in which he was scarcely Leonardo's inferior, enabled him to make use of rich and full-bodied colours, which are never gaudy, as sometimes with Bonifazio, or pretty, as with Catena and lesser artists. Nor is he decorative in the way that Veronese excels, or lurid like Tintoretto. Compared with Titian it is as though his colour-chord sounded in seven sharps, whilst the former strikes the key of C natural. A full rich green frequently occurs, as in the Castelfranco "Madonna" and the Louvre picture, and a deep crimson, contrasting with pure white drapery, or with golden flesh-tints, is also characteristic. In the painting of the nude he gives us real flesh and blood; his "Venus" has not the supernatural radiance that Correggio can give his ethereal beings (Giorgione, by the way,

never painted an angel, so far as we know), but she glows with actual life, the blood is pulsing through the veins, she is very real. And in this connection we may notice the extraordinary skill with which Giorgione conveys a sense of texture; his painting of rich brocades, and more especially quilted stuffs and satiny folds, cannot be surpassed even by a Terburg.

The quality of line in his work makes itself felt in many ways. Beauty of contour and unbroken continuity of curve is obtained sometimes by sacrificing literal accuracy; a structurally impossible position—as the seated nude figure in the Louvre picture—is deliberately adopted to heighten the effect of line or the balance of composition. The Dresden "Venus," if she arose, would appear of strange proportions; but expressiveness is enhanced by the long flowing contours of the body, so suggestive of repose. We may notice also the emphasis obtained by parallelism; for example, the line of the left arm of the "Venus" follows the curve of the body, a trick which may be often seen in folds of drapery. This picture also illustrates a device to retain continuity of line; the right foot is hidden away so as not to interfere with the contour. Exactly the same thing may be seen in the standing figure in the Louvre "Pastoral Symphony." The trick of making a grand sweep from the top of the head downwards is usually found in the Madonna pictures, where a cunningly placed veil carries the line usually to the sloping shoulders, or else outwards to the point of the elbow, thus introducing the triangular scheme to which Giorgione was particularly partial.

But the question remains, What is Giorgione's position among the world's great men? Is he intellectually to be ranked with the Great Thinkers of all time? Can he aspire to the position which Titian occupies? I fear not Beethoven is infinitely greater than Schubert, Shakespeare than Keats, and so, though in lesser degree, is Titian than Giorgione. I say in lesser degree, because the young poet-painter had something of that profound insight into human nature, something of that wide outlook on life, something of that universal sympathy, and something of that vast influence which distinguishes the greatest intellects of all, and this it is which lessens the distance between him and Titian. Yet Titian is the greater man, for he is "the highest and completest expression of his own age."[147]

Nevertheless, in that narrower sphere of the great painters, who proclaimed the glad tidings of Liberty when the Spirit of Man awoke from

Mediaevalism, may we not add yet a fifth voice to the four-part harmony of Raphael, Correggio, Leonardo, and Michel Angelo, the voice of Giorgione, the wondrous youth, "the George of Georges," who heralded the Renaissance of which we are the heirs?

NOTES:

[138]

In the Church of San Rocco, Venice, and in Mrs. Gardner's Collection in America.

[139]

Keats died at the age of twenty-five; Schubert was thirty-one; Giorgione thirty-three.

[140]

The ruined condition of the Borghese "Lady" prevents any just appreciation of the interpretative qualities.

[141]

Venetian Painters, p. 30.

[142]

Leonardo, 1452-1519; Michel Angelo, 1475-1564; Giorgione, 1477-1510; Raphael, 1483-1520; Correggio, 1494-1534. Correggio, Raphael, and Giorgione died at the ages of forty, thirty-seven, and thirty-three years respectively. Those whom the gods love die young!

[143]

Berenson: *Venetian Painters*, p. 29. I should prefer to substitute "ripening" for "ripened."

[144]

Fry: *Giovanni Bellini*, p. 44.

[145]

In S. Giovanni Crisostomo, Venice. It dates from 1513.

[146]

Mary Logan: *Guide to the Italian Pictures at Hampton Court*, p. 13.

[147]

Berenson: *Venetian Painters*, p. 48.

APPENDIX I

DOCUMENTS

The following correspondence between Isabella d'Este, Marchioness of Mantua, and her agent Albano in Venice, is reprinted from the *Archivio Storico dell' Arte*, 1888, p. 47 (article by Sig. Alessandro Luzio):—

"Sp. Amice noster charissime; Intendemo che in le cose et heredità de Zorzo da Castelfrancho pictore se ritrova una pictura de una nocte, molto bella et singulare; quando cossì fusse, desideraressimo haverla, però vi pregamo che voliati essere cum Lorenzo da Pavia et qualche altro che habbi judicio et designo, et vedere se l'è cosa excellente, et trovando de sì operiati il megio del m'co m. Carlo Valerio, nostro compatre charissimo, et de chi altro vi parerà per apostar questa pictura per noi, intendendo il precio et dandone aviso. Et quando vi paresse de concludere il mercato, essendo cosa bona, per dubio non fusse levata da altri, fati quel che ve parerà: chè ne rendemo certe fareti cum ogni avantagio e fede et cum bona consulta. Ofteremone a vostri piaceri ecc.

"Mantua xxv. oct MDX."

The agent replies a few days later—

"Illma et Excma Ma mia obserma

"Ho inteso quanto mi scrive la Ex. V. per una sua de xxv. del passatto, facendome intender haver inteso ritrovarsi in le cosse et eredità del q. Zorzo de Castelfrancho una pictura de una notte, molto bella et singulare; che essendo cossì si deba veder de haverla.

"A che rispondo a V. Ex. che ditto Zorzo morì più dì fanno da peste, et per voler servir quella ho parlato cum alcuni mei amizi, che havevano grandissime praticha cum lui, quali me affirmano non esser in ditta heredità tal pictura. Ben è vero che ditto Zorzo ne feze una a m. Thadeo Contarini, qual per la informatione ho autta non è molto perfecta sichondo vorebe quela. Un'altra pictura de la nocte feze ditto Zorzo a uno Victorio Becharo, qual per quanto intendo è de meglior desegnio et meglio finitta che non è quella del Contarini. Ma esso Becharo, al presente non si atrova in questa terra, et sichondo m'è stato afirmatto nè l'una nè l'altra non sono da vendere

per pretio nesuno; però che li hanno fatte fare per volerle godere per loro; sichè mi doglio non poter satisfar al dexiderio de quella ecc.

"Venetijs viii Novembris 1510.

"Servitor

"THADEUS ALBANUS."

From this letter we learn definitely (1) that Giorgione died in October-November 1510; (2) that he died of the plague.

I have pointed out in the text that the above description of the two pictures "de una notte" corresponds with the actual Beaumont and Vienna "Nativities," or "Adoration of the Shepherds," in which I recognise the hand of Giorgione.

The following is the only existing document in Giorgione's own handwriting. It was published by Molmenti in the *Bollettino delle Arti*, anno ii. No. 2, and reprinted by Conti, p. 50:—

"El se dichiara per el presente come el clarissimo Messer Aluixe di Sesti die a fare a mi Zorzon de Castelfrancho quatro quadri in quadrato con le geste di Daniele in bona pictura su telle, et li telleri sarano soministrati per dito m. Aluixe, il quale doveva stabilir la spexa di detti quadri quando serano compidi et di sua satisfatione entro il presente anno 1508.

"Io Zorzon de Castelfrancho di mia man scrissi la presente in Venetia li 13 febrar 1508."

Whether or no Giorgione ever completed these four square canvases with the story of Daniel is unknown. There is no trace of any such pictures in modern times.

APPENDIX II

DID TITIAN LIVE TO BE NINETY-NINE YEARS OLD?

Reprinted from the "Nineteenth Century" Jan. 1902

There is something fascinating in the popular belief that Titian, the greatest of all Venetian painters, reached the patriarchal age of ninety-nine years, and was actively at work up to the day of his death. The text-books love to tell us the story of the great unfinished "Pietà" with its pathetic inscription:

Quod Titianus inchoatum reliquitPalma reverenter absolvitDeoq. dicavit opus;

and traveller, guide-book in hand, and moralist, philosophy in head, alike muse upon a phenomenon so startlingly at variance with common experience.[148]

But, sentiment aside, is there any historical evidence that Titian ever worked at his art in his hundredth year? that he even attained such a venerable age? The answer is of wider consequence than the mere question implies, for on the correct determination of Titian's own chronology depends the history of the development of the entire Venetian school of painting in the early years of the sixteenth century. I say *early*, because it is the date of Titian's birth, and not that of his death, which I shall endeavour to fix; the latter event is known beyond possibility of doubt to have occurred in August 1576. The question, therefore, to consider is, what justification, if any, is there for the universal belief that Titian was born in 1476-7, just a hundred years previously?

Anyone, I think, who has ever looked into the history of Titian's career must have been struck by the fact that for the first thirty-five years of his life (according to the usual chronology) there is absolutely no documentary record relating to him, whether in the Venetian archives or elsewhere. Not a single letter, not a single contract, not a single mention of his name occurs from which we can so much as affirm his existence before the year 1511.

On the 2nd of December in that year "Io tician di Cador Dpñtore" gives a receipt for money paid him on completion of some frescoes at Padua, and from this date on there are frequent letters and documents in existence right down to 1576, the year of his death. Is it not somewhat strange that the first thirty-five years of his life (as is commonly believed) should be a total

blank so far as records go? The fact becomes the more inexplicable when we find that during these early years some of his finest work is alleged to have been executed, and he must—if we accept the chronology of his biographers—have been well known to and highly esteemed by his contemporaries.[149] Moreover, it is not for want of diligent search amongst the archives that nothing has been found, for Italian and German students have alike sought, but in vain, to discover any documentary evidence relating to his career before 1511.

The absence of any such trustworthy record has had its natural result. Conjecture has run riot, and no two writers are agreed on the subject of the nature and development of Titian's earlier art. This is the second disquieting fact which any careful student has to face. Messrs. Crowe and Cavalcaselle, Titian's most exhaustive biographers,[150] have filled up the first thirty-five years of his career in their own way, but their chronology has found no favour with later writers, such as Mr. Claude Phillips in England[151] or Dr. Georg Gronau in Germany,[152] both of whom have arrived at independent conclusions. Morelli again had his theories on the subject, and M. Lafenestre[153] has his, and the ordinary gallery catalogue is usually content to state inaccurate facts without further ado.

Now, if all these conscientious writers arrive at results so widely divergent, either their logic or their data must be wrong! One and all assume that Titian lived into his hundredth year, and, therefore, was born in 1476-7; and starting with this theory as a fact, they have tried to fit in Vasari's account as best they can, and each has found a different solution of the problem. There is only one way out of this chaos of conjectures—we must see what is the evidence for the "centenarian" tradition, and if it can be shown that Titian was really born later than 1476-7, then the silence of all records about him during an alleged period of thirty-five years will become at once more intelligible, and we may be able to explain some of the other anomalies which at present confront Titian's biographers.

I propose to take the evidence in strictly chronological order.

The oldest contemporary account of Titian's career is furnished by Lodovico Dolce in his *L'Aretino, o dialogo della pittura*, which was published at Venice in 1557. Dolce knew Titian personally, and wrote his treatise just at the time when the painter was at the zenith of his fame. He is our sole

authority for certain incidents of Titian's early career: it will be well, therefore, to quote in full the opening paragraphs of his narrative:

"Being born at Cadore of honourable parents, he was sent when a child of nine years old by his father to Venice to the house of his father's brother ... in order that he might be put under some proper master to study painting; his father having perceived in him even at that tender age strong marks of genius towards the art.... His uncle directly carried the child to the house of Sebastiano, father of the *gentilissimo* Valerio and of Francesco Zuccati (distinguished masters of the art of mosaic, by them brought to that perfection in which we now see the best pictures) to learn the principles of the art. From them he was removed to Gentile Bellini, brother of Giovanni, but much inferior to him, who at that time was at work with his brother in the Grand Council-Chamber. But Titian, impelled by Nature to greater excellence and perfection in his art, could not endure following the dry and laboured manner of Gentile, but designed with boldness and expedition. Whereupon Gentile told him he would make no progress in painting, because he diverged so much from the old style. Thereupon Titian left the stupid *(goffo)* Gentile, and found means to attach himself to Giovanni Bellini; but not perfectly pleased with his manner, he chose Giorgio da Castel Franco. Titian then drawing and painting with Giorgione, as he was called, became in a short time so accomplished in art, that when Giorgione was painting the façade of the Fondaco de' Tedeschi, or Exchange of the German Merchants, which looks towards the Grand Canal, Titian was allotted the other side which faces the market-place, being at the time scarcely twenty years old. Here he represented a Judith of wonderful design and colour, so remarkable, indeed, that when the work came to be uncovered, it was commonly thought to be the work of Giorgione, and all the latter's friends congratulated him as being by far the best thing he had produced. Whereupon Giorgione, in great displeasure, replied that the work was from the hand of his pupil, who showed already how he could surpass his master, and, what was more, Giorgione shut himself up for some days at home, as if in despair, seeing that a young man knew more that he did."

Fortunately, the exact date can be fixed when the frescoes on the Fondaco de' Tedeschi were painted, for we have original records preserved from which we learn the work was begun in 1507 and completed towards the

close of 1508.[154] If Titian, then, was "scarcely twenty years old" in 1507-8, he must have been born in 1488-9. Dolce particularly emphasises his youthfulness at the time, calling him *un giovanetto*, a phrase he twice applies to him in the next paragraph, when he is describing the famous altar-piece of the 'Assunta,' the commission for which, as we know from other sources, was given in 1516.

"Not long afterwards he was commissioned to paint a large picture for the High Altar of the Church of the Frati Minori, where Titian, quite a young man *(pur giovanetto)*, painted in oil the Virgin ascending to Heaven.... This was the first public work which he painted in oil, and he did it in a very short time, and while still a young man *(e giovanetto)*."

This phrase could hardly be applied to a man over thirty, so that Titian's birth cannot reasonably be dated before 1486 or so, and is much more likely to fall later. The previous deduction that it was 1488-9 is thus further strengthened.

The evidence, then, of Dolce, writing in 1557, is clear and consistent: Titian was born in 1488-9. Now let us see what is stated by Vasari, who is the next oldest authority.

The first edition of the *Lives* appeared in 1550—that is, just prior to Dolce's *Dialogue*—but a revised and enlarged edition appeared in 1568, in which important evidence occurs as to Titian's age. After enumerating certain pictures by the great Venetian, Vasari adds:

"(*a*) All these works, with many others which I omit, to avoid prolixity, have been executed up to the present age of our artist, which is above seventy-six years.... In the year 1566, when Vasari, the writer of the present history, was at Venice, he went to visit Titian, as one who was his friend, and found him, although then very old, still with the pencil in his hand, and painting busily."[155]

According to Vasari, then, Titian was "above seventy-six years" when the second edition of the *Lives* was written, and as from the explicit nature of the evidence this must have been between 1566, when he visited Venice, and January 1568, when his book was published, it follows that Titian was "above seventy-six years" in 1566-7—in other words, that he was born 1489-90.

Still confining ourselves to Vasari, we find two other passages bearing on the question:

"(*b*) Titian was born in the year 1480 at Cadore.[156]

"(*c*) About the year 1507 Giorgione da Castel Franco began to give to his works unwonted softness and relief, painting them in a very beautiful manner.... Having seen the manner of Giorgione, Titian early resolved to abandon that of Gian Bellino, although well grounded therein. He now, therefore, devoted himself to this purpose, and in a short time so closely imitated Giorgione that his pictures were sometimes taken for those of that master.... At the time when Titian began to adopt the manner of Giorgione, being then not more than eighteen, he took the portrait," etc.[157]

This passage (*c*) makes Titian "not more than eighteen about the year 1507," and fixes the date of his birth as 1489-90, therein agreeing with the previous deduction at which we arrived when examining the passage in Vasari's second edition. Thus in two places out of three Vasari is consistent in fixing 1489-90 as the date. How, then, explain (*b*), which explicitly gives 1480?

Anyone conversant with Vasari's inaccuracies will hardly be surprised to find that this statement is dismissed by all Titian's biographers as manifestly a mistake. Moreover, it is inconsistent with the two passages just quoted, and either they are wrong or 1480 is a misprint for 1489. Now, from the nature of the evidence recorded by Vasari, it cannot be a matter for any doubt which is the more trustworthy statement. On the one hand, he speaks as an eye-witness of Titian's old age, and is careful to record the exact year he visited Venice and the age of the painter; on the other hand, he makes a bald statement which he certainly cannot have verified, and which is inconsistent with his own experience! In any case, in Vasari's text the evidence is two to one in favour of 1489-90 as the right date, and thus we come to the agreeable conclusion that our two oldest authorities, Dolce and Vasari, are at one in fixing Titian's birth between 1488 and 1490—in other words, about 1489.

So far, then, all is clear, and as we know from later and indisputable evidence that Titian died in 1576, it follows that he only attained the age of eighty-seven and not ninety-nine. Whence, then, comes the story of the ninety-nine years? From none other than Titian himself, and to this piece of evidence we must next turn, following out a strict chronological order.

In 1571—that is, three years after Vasari's second edition was published—Titian addresses a letter to Philip the Second of Spain in these

terms:[158]

"Most potent and invincible King,—I think your Majesty will have received by this the picture of 'Lucretia and Tarquin' which was to have been presented by the Venetian Ambassador. I now come with these lines to ask your Majesty to deign to command that I should be informed as to what pleasure it has given. The calamities of the present times, in which every one is suffering from the continuance of war, force me to this step, and oblige me at the same time to ask to be favoured with some kind proof of your Majesty's grace, as well as with some assistance from Spain or elsewhere, since I have not been able for years past to obtain any payment either from the Naples grant, or from my ordinary pension. The state of my affairs is indeed such that I do not know how to live in this my old age, devoted as it entirely is to the service of your Catholic Majesty, and to no other. Not having for eighteen years past received a *quattrino* for the paintings which I delivered from time to time, and of which I forward a list by this opportunity to the secretary Perez, I feel assured that your Majesty's infinite clemency will cause a careful consideration to be made of the services of an old servant of the age of ninety-five, by extending to him some evidence of munificence and liberality. Sending two prints of the design of the Beato Lorenzo, and most humbly recommending myself,

"I am Your Catholic Majesty's

"most devoted, humble servant,

"TITIANO VECELLIO.

"From Venice, the 1st of August, 1571."

Here, then, is Titian himself, in the year 1571, declaring that he is ninety-five years of age—in other words, dating his birth back to 1476—that is, some thirteen years earlier than Dolce and Vasari imply was the case. A flagrant discrepancy of evidence! In similar strain he thus addresses the king again five years later:[159]

"Your Catholic and Royal Majesty,—The infinite benignity with which your Catholic Majesty—by natural habit—is accustomed to gratify all

such as have served and still serve your Majesty faithfully, enboldens me to appear with the present (letter) to recall myself to your royal memory, in which I believe that my old and devoted service will have kept me unaltered. My prayer is this: twenty years have elapsed and I have never had any recompense for the many pictures sent on divers occasions to your Majesty; but having received intelligence from the Secretary Antonio Perez of your Majesty's wish to gratify me, and having reached a great old age not without privations, I now humbly beg that your Majesty will deign, with accustomed benevolence, to give such directions to ministers as will relieve my want. The glorious memory of Charles the Fifth, your Majesty's father, having numbered me amongst his familiar, nay, most faithful servants, by honouring me beyond my deserts with the title of *cavaliere*, I wish to be able, with the favour and protection of your Majesty—true portrait of that immortal emperor—to support as it deserves the name of a cavaliere, which is so honoured and esteemed in the world; and that it may be known that the services done by me during many years to the most serene house of Austria have met with grateful return, to spend what remains of my days in the service of your Majesty. For this I should feel the more obliged, as I should thus be consoled in my old age, whilst praying to God to concede to your Majesty a long and happy life with increase of his divine grace and exaltation of your Majesty's Kingdom. In the meanwhile I expect from the royal benevolence of your Majesty the fruits of the favour I desire, with due reverence and humility, and kissing your sacred hands,

"I am Your Catholic Majesty's

"most humble and devoted servant,

"TITIANO VECELLIO.

"From Venice, the 27th of February, 1576."

This is the last letter we have of Titian, who died in August of this year, according to his own showing, in his hundredth year.

Now what reliance can be placed on this statement? On the one hand, we have the evidence of two independent writers, Dolce and Vasari, both personally acquainted with Titian, and both agreeing by inference that the date of his birth was about 1489. Both had ample opportunity to get at the truth, and Vasari is particularly explicit in recording the exact date when he visited Titian in Venice and the age the painter had then reached. Yet five

years later Titian is found stating that he is ninety-five, and not eighty-two as we should expect! Perhaps the best comment is made by Crowe and Cavalcaselle, who significantly remark immediately after the last letter "Titian's appeal to the benevolence of the King of Spain looks like that of a garrulous old gentleman proud of his longevity, but hoping still to live for many years."[160] Exactly! The occasion could well be improved by a little timely exaggeration well calculated to appeal to the sympathies and "infinite benignity" of the monarch, and if, when the writer had actually reached the respectable age of eighty-two, he wrote himself down as ninety-five, who would gainsay him? It added point to his appeal—that was the chief thing—and as to accuracy, well, Titian was not the man to be over-scrupulous when his own interests were involved. But even though the statement were not deliberately made to heighten the effect of an appeal, we must in any case make allowances for the natural proneness to exaggerate their age which usually characterises men of advanced years, so that any *ex parte* statement of this kind must be received with due caution. Where, moreover, as in the present case, we have evidence of a directly contradictory kind furnished by independent witnesses, whose declarations in this respect are presumably disinterested, such *ex parte* statements are on the face of them unreliable. The balance of evidence in this case appears to rest on the side of the older historians, Dolce and Vasari, whose statements, as I hold, are in the circumstances more reliable than the picturesque exaggeration of a man of advanced years.

 I claim, therefore, that any account of Titian's life based solely on such flimsy evidence as to his age as is found in this letter to Philip the Second is, to say the least, open to grave doubt. The whole superstructure raised by modern writers on this uncertain foundation is full of flaws and incongruities, and I am fully persuaded the future historian will have to begin *de novo* in any attempt at a chronological reconstruction of Titian's career. The gap of thirty-five years down to 1511 may prove after all less by twelve or thirteen years than people think, so that the young Titian naturally enough first emerges into view at the age of twenty-two and not thirty-five.

 But we must not anticipate results, for there is still the evidence of the later writers of the seventeenth century to consider. Two of these declare that Titian was born in 1477. The first of these, Tizianello, a collateral descendant

of the great painter, published his little *Compendio* in 1622, wherein he gives a sketchy and imperfect biography; the other, Ridolfi, repeats the date in his *Meraviglie dell' Arte*, published in 1648. The latter writer is notoriously unreliable in other respects, and it is quite likely this is merely an instance of copying from Tizianello, whose unsupported statement is chiefly of value as showing that the "centenarian" theory had started within fifty years of Titian's death. But again we ask: Why should the evidence of a seventeenth-century writer be preferred to the personal testimony of those who actually knew Titian himself, especially when Vasari gives us precise information with which Dolce's independent account is in perfect agreement? No doubt the great age to which Titian certainly attained was exaggerated in the next generation after his death, but it is a remarkable fact that the contemporary eulogies, mostly in poetic form, which appeared on the occasion of his decease, do not allude to any such phenomenal longevity.[161]

Nevertheless, Ridolfi's statement that Titian was born in 1477 is commonly quoted as if there were no better and earlier evidence in existence, and, indeed, it is a matter of surprise that conscientious modern biographers have not looked more carefully at the original authorities instead of being content to follow tradition, and I must earnestly plead for a reconsideration of the question of Titian's age by the future historians of Venetian painting.[162]

If, as I believe, Titian was born in or about 1489 instead of 1476-7, it follows that he must have been Giorgione's junior by at least twelve years—a most important deduction—and it also follows that he cannot have produced any work of consequence before, say, 1505, at the age of sixteen, and he will have died at eighty-seven and not in his hundredth year. The alteration in date would help to explain the silence of all records about him before 1511, when he would have been only twenty-two and not thirty-five years old; it would fully account for his name not being mentioned by Dürer in his famous letter of 1506, wherein he refers to the painters of Venice, and it would equally account for the absence of his name from the commission to paint the Fondaco frescoes in 1507-8, for he would have been employed simply as Giorgione's young assistant. The fact that in 1511 he signs himself simply "Io tician di Cador Dpñtore" and not *Maestro* would be more intelligible in a young man of twenty-two than in an accomplished master of

thirty-five, and the character of his letter addressed to the Senate in 1513 would be more natural to an ambitious aspirant of twenty-four than to a man in his maturity of thirty-seven.[163]

Such are some of the obvious results of a change of date, but the larger question as to the development of Titian's art must be left to the future historian, for the importance of fixing a date lies in the application thereof.[164]
HERBERT COOK.

THE DATE OF TITIAN'S BIRTH

Reply by Dr. Georg Gronau. Translated from the "Repertorium für Kunstwissenschaft," vol. xxiv., 6th part

In the January number of the *Nineteenth Century* appears an article by Herbert Cook under the title, "Did Titian live to be Ninety-Nine Years Old?" The interrogation already suggests that the author comes to a negative conclusion. It is, perhaps, not without interest to set forth the reasons advanced by the English connoisseur and to submit them to adverse criticism.

(Here follows an abstract of the article.)

The reasoning, as will have been seen, is not altogether free from doubt. It has been usual hitherto in historical investigations to call in question the assertions of a man about his own life only when thoroughly weighty reasons justified such a course. Is the evidence of a Dolce and of a Vasari so free from all objection that it outweighs Titian's personal statement? Before answering this question it should be pointed out that we possess two further statements of contemporary writers on the subject of Titian's age, statements which have escaped the notice of Mr. Cook. One is to be found in a letter from the Spanish Consul in Venice, Thomas de Cornoga, to Philip II., dated 8th December 1567 (published in the very important work by Zarco del

Valle[165]). After informing the king of Titian's usual requests on the subject of his pension, and so on, he continues: "y con los 85 annos de su edad servira à V.M. hasta la muerte."

Somewhere, then, in the very year in which Titian, according to Vasari, was "above seventy-six years of age," he seems to have been eighty-five, according to the report of another and quite independent witness, and if so, he would have been born about 1482.

We have then three definite statements:

Vasari (1566 or 1567) says "over 76" The Consul (1567) " "85" Titian himself (1571) " "95" This new information, instead of helping us, only serves to make still greater confusion.

The other piece of evidence not mentioned by Mr. Cook was written only a few years after Titian's death. Borghini says in his *Riposo*, 1584: "Mori ultimamente di vecchiezza (!not, then, of the plague?), essendo d'età d'anni 98 o 99, l'anno 1576." ... This is the first time that the traditional statement as to the master's age appears in literature. In this state of things it is worth while to look closer into the evidence of Dolce and Vasari to see if they are not after all the most trustworthy witnesses.

It is always held to be a mistake to take rather vague statements quite literally, as Mr. Cook has done, and to build thereon further conclusions. When Dolce says that Titian painted with Giorgione at the Fondaco, "non avendo egli allora appena venti anni," he is only trying to make out that his hero, here as everywhere, was a most unusual person (the whole dialogue is a glorification of the master). For the same reason he makes the following remark, which we can absolutely prove to be false:—the Assumption (he says) "fu la prima opera pubblica, che a olio facesse." Now at least one work of Titian's was, then, already to be seen in a public place—viz. the "St. Mark Enthroned, with Four Saints," in Santo Spirito, afterwards removed to the sacristy of the Salute. In other points, too, Dolce can be convicted of small errors and misrepresentations, partly on literary grounds, partly due to his desire to enhance the praise of Titian.

Vasari, again, should only be cited as witness when he speaks of works of art which he has actually seen. In such a case, apart from slips, he is always a trustworthy guide. Directly, however, he goes into biographical

details or questions of chronology accuracy becomes nearly always a secondary matter. Titian's biography offers an excellent and most instructive example of this. Vasari mentions first the birth and upbringing of the boy, then he speaks of Giorgione and the Fondaco frescoes, and goes on: "dopo la quale opera fece un quadro grande che oggi è nella salla di messer Andrea Loredano.... Dopo in casa di messer Giovanni D'Anna ... fece il suo ritratto ...; ed un quadro di Ecce Homo, ..." and he goes on, "L'anno poi 1507...." If it had not been that one of these pictures, once in the possession of Giovanni D'Anna, had been preserved (now in the Vienna Gallery), and that it bears in a conspicuous place the date 1543, it would be recorded in all biographies of Titian that he painted in 1507 an "Ecce Homo" for this Giovanni D'Anna.

If one goes further into Vasari's account we read that Titian published his "Triumph of Faith" in 1508. "Dopo condottosi Tiziano a Vicenza, dipinse a fresco sotto la loggetta ... il giudizio di Salamone. Appresso tomato a Venezia, dipinse la facciata de' Grimani; e in Padoa nella chiesa di Sant' Antonio alcune storie ... de fatti di quel santo: e in quella di Santo Spirito fece ... un San Marco a sedere in mezzo a certi Santi." We now know on documentary evidence that the Vicenza fresco (which was destroyed later) dated from 1521, and similarly that the frescoes at Padua were painted in 1511, whilst the date of the S. Mark picture may be fixed with probability at 1504.

These examples prove how inexact Vasari is here once more. But it may be objected, supposing that he is inaccurate in statements which refer back, can he not be in the right in a case where he comes back, so to speak, straight from visiting Titian and writes down his observation about the master's actual age? To be sure; but when we find that so many other similar notices of Vasari are wrong, even those that refer to people whom he personally knew, we lose faith altogether. In turning over the leaves of the sixth volume of the Sansoni edition of Vasari, in which only his contemporaries, some of them closely connected, too, with him, are spoken of, we find the following incorrect statements:—

P. 99. Tribolo was 65 years old (in reality only 50).

P. 209. Bugiardini died at 75 (really 79).

P. 288. Pontormo at 65 (he died actually in his 63rd year).

P. 564. Giovanni da Udine at 70 (really 77).

A still more glaring instance is to be found when Vasari not only makes misstatements about his own life but is actually out by several years in giving his own age. One and the same event—viz. his journey with Cardinal Passerini to Florence—is given in his own autobiography to the year 1524, in the "Life of Salviati," to the year 1523, and in the "Life of Michael Angelo" to 1525. When he speaks of himself in the same passage in the "Life of Salviati" as the "putto, che allora non aveva più di nove anni," he is making a mistake of at least three years in his own age. And not less delightful is it to read in the "Life of Giovanni da Udine": "Giorgio Vasari, giovinetto di diciotto anni, quando serviva il duca Alessandro de' Medici suo primo signore l'anno 1535." We are obviously not dealing with Messer Giorgio's strongest point, for, as a matter of fact, he was at that time twenty-four years of age! The same false statement of age is found again in his own biography (vii. p. 656, with the variation, "poco piú di diciotto anni").

But I think these instances suffice to prove how little one dare build on such assertions of Vasari. Who dare say if Titian was really only seventy-six in 1566 when the Aretine visited him?

And now a few remarks on the other points raised by Mr. Cook. As a fact, it is an astonishing thing that we have no documentary evidence about Titian before 1511; but does he not share this fate with very many of his great countrymen, with Bellini, Giorgione, Sebastiano, and others? An unfriendly chance has left us entirely in the dark as to the early years of nearly all the great Venetian painters. That Dürer makes no mention of Titian's name in his letters gives no cause for surprise, for even the most celebrated of the younger artists, Giorgione, is not alluded to, and of all those with Bellini, whose fame outshone even then that of all others, only Barbari is mentioned. That Titian's name does not occur in the documents about the Fondaco frescoes may be due to the fact that Giorgione alone was commissioned to undertake the frescoes for the magistrates, and that the latter painter in his turn brought his associate Titian into the work.

Mr. Cook says that Titian still signed himself in 1511 "Dipintore"

instead of "Maestro." I am not aware whether in this respect definite regulations or customs were usual in Venice.[166] At any rate, the painter is still described in official documents as late as 1518 as "ser Tizian depentor" (Lorenzi, "Monumenti," No. 366), when, even according to Mr. Cook's theory, he must have been thirty years old; and he is actually so called in 1528 (*ibid.* No. 403), after appearing in several intermediate documents as "maestro" (Nos. 373, 377). If this argument, however, proves unsound, the last point—viz. that the well-known petition to the senate in 1513 reads more like that of a man of twenty-four than one of thirty-seven—must be left to the hypothesis of individual conjecture.

Must we really close these very long inquiries by confessing they are beyond our ken? It almost seems so. For, with regard to the testimony afforded by family documents, Dr. Jacobi (whose labours were utilised by Crowe and Cavalcaselle) so conscientiously examined all that is left, that a discovery in this direction is not to be looked for. Is the statement of Tizianello that Titian's year of birth was 1477 to be rejected without further question when we remember that, as a relative of the painter, he could have had in 1622 access to documents possibly since lost?

Under these circumstances the only thing left to do is to question the works of Titian. Of these, two can be dated, not indeed with certainty, but with some degree of probability: the dedicatory painting of the Bishop of Pesaro with the portrait of Alexander VI. of 1502-03, and the picture of St. Mark, already mentioned, of the year 1504. Both are, to judge by the style, clearly early works, and both can be connected with definite historical events of the years just mentioned. That these paintings, however, could be the work of a fourteen- to fifteen-year-old artist Mr. Cook will also admit to be impossible.

Much, far too much, in the story of Venetian painting must, for want of definite information, be left to conjecture; and however unsatisfactory it is, we must make the confession that we know as little about the date of the birth of the greatest of the Venetians as we know of Giorgione's, Sebastiano's, Palma's, and the rest. But supposing all of a sudden information turned up giving us the exact date of Titian's birth, would the picture of the development of Venetian painting be any the different for it? In no wise. The relation to one another of the individual artists of the younger generation is

so clearly to be read in each man's work, that no external particulars, however interesting they might be on other grounds, could make the smallest difference. Titian's relations with Giorgione especially could not be otherwise represented than has been long determined, and that whether Titian was born in 1476, 1477, 1480, or even two or three years later.[167] GEORG GRONAU.

WHEN WAS TITIAN BORN?

Reply to Dr. Gronau. Reprinted from "Repertorium für Kunstwissenschaft," vol. xxv., parts 1 and 2

I must thank Dr. Georg Gronau for his very fair reply, published in these pages[168] (to my article in the *Nineteenth Century* on the subject of Titian's age[169]). He has also most kindly pointed out two pieces of contemporary evidence which had escaped my notice, and although neither of these passages is conclusive proof one way or the other, they deserve to be reckoned with in arriving at a decision.

Dr. Gronau formulates the evidence shortly thus:

Vasari in 1566 or 1567 says Titian is over 76 The Spanish Consul in 1567 " " " 85 Titian himself in 1571 " he is " 95

and he adds that this new piece of evidence—viz. the letter of the Spanish Consul to King Philip—instead of helping us, only makes the confusion worse.

What then are we to think when yet another—a fourth—contemporary statement turns up, differing from any of the three just quoted? Yet such a letter exists, and I am happy in my turn to point out this fresh piece of evidence, in the hope that instead of making the confusion worse, it will help us to arrive at some decision.

On October the 15th, 1564, Garcia Hernandez, Envoy in Venice

from King Philip II., writes to the King his master that Titian begged that His Majesty would condescend to order that he should be paid what was due to him from the court and from Milan.... For the rest the painter was in fine condition, and quite capable of work, and this was the time, if ever, to get "other things" from him, as according to some people who knew him, Titian was about ninety years old, though he did not show it, and for money everything was to be had of him.[170]

In 1564 then the Spanish Envoy writes that Titian was said to be about ninety. Let us then enlarge Dr. Gronau's table by this additional statement, and further complete it by including the earliest piece of evidence, the statement of Dolce in 1557 that Titian was scarcely twenty when he worked at the Fondaco de' Tedeschi frescoes (1507-8). The year of Titian's birth thus works out:

Writing in 1557
Dolce
makes out Titian was born about 1489
"
1566-7
Vasari
"
1489
"
1564
Spanish Envoy
"
1474
"
1567
Spanish Consul
"
1482
"
1571

Titian himself
"
1476

Now it is curious to notice that the last three statements are all made in letters to King Philip, either by Titian himself, or at his request by the Spanish agents.

It is curious to notice these statements as to Titian's great age occur in begging letters.[171]

It is curious to notice they are mutually contradictory.

What are we to conclude?

Surely that the Spanish Envoy, the Spanish Consul, and Titian himself, out of their own mouths stand convicted of inconsistency of statement, and further that they betray an identical motive underlying each representation—viz. an appeal *ad misericordiam*.

Before, however, contrasting the value of the evidence as found in these Spanish letters with the evidence as found in Dolce and Vasari, let us note two points in these letters.

Garcia Hernandez, the Spanish Envoy, writes: "According to some people who knew him, Titian was about ninety years old, though he did not show it." Now, if Titian was really about ninety in the year 1564, he will have lived to the age of one hundred and two, a feat of longevity of which no one has ever accused him! Apart, therefore, from the healthy scepticism which Hernandez betrays in this letter, we may certainly conclude that "some people who knew him" were exaggerating Titian's age.

Secondly, Titian's letter of 1571 says he is ninety-five years old. Titian's similar letter of 1576, the year of his death, omits to say he is one hundred. Surely a strange omission, considering that he refers to his old age three times in this one letter.[172] Does not the second letter correct the inexactness of the first? and so Titian's statement goes for nothing?

The collective evidence, then, of these Spanish letters amounts to this, that, in the words of the Envoy, "for money everything was to be had of Titian," and accordingly any statement as to his great age when thus made for effect must be treated with the greatest suspicion.

But is the evidence of Dolce and Vasari any more trustworthy? Dr.

Gronau is at pains to show that both these writers often made mistakes in their dates, a fact which no one can dispute. Their very incorrectness is the more reason however for trusting them in this instance, for they happen to agree about the date of Titian's birth; and, although neither of them expressly gives the year 1489, they indicate separate and independent events in his life, the one, Dolce, at the beginning, the other, Vasari, at the end, which when looked into give the same result.

Moreover, be Dolce ever so anxious to cry up his hero Titian, and make him out to have been precocious, and be Vasari ever so inexact in his chronology, we must remember that, when both of them wrote, the presumption of unusual longevity had not arisen, and that their evidence therefore is less likely to be prejudiced in this respect than the evidence given in obituary notices, such as occurs in Borghini's *Riposo* of 1584, and in the later writers like Tizianello and Ridolfi.

That Borghini therefore says Titian was ninety-eight or ninety-nine when he died, and that Tizianello and Ridolfi, thirty-eight and sixty-four years later respectively, put him down at ninety-nine, is by no means proof that such was the case. It would seem that there had been some speculation before and after Titian's death as to his exact age; that no one quite knew for certain; and that Titian with the credulousness of old age had come to regard himself as well-nigh a centenarian. Be this as it may, I still hold that the evidence of Dolce and Vasari that Titian's birth occurred in 1489 is more trustworthy than either the evidence found in the three Spanish letters, or the evidence as given in the obituary notices of Borghini and others.

One word more. If Titian was born in 1489, instead of 1476-7, it does make a great difference in the story of his own career; and, what is more, the history of Venetian art in the early sixteenth century, as it centres round Giorgione, Palma, and Titian, will have to be carefully reconsidered.

HERBERT COOK.

NOTES:

[148]
The picture now hangs in the Academia at Venice.

[149]

E.g. the "Sacred and Profane Love" (so-called) in the Borghese Gallery; the "S. Mark" of the Salute; the "Concert" in the Pitti; the "Tribute Money" at Dresden; the "Madonna of the Cherries" at Vienna, etc., which one or other of his biographers assign to the years 1500-1510.

[150]

The Life and Times of Titian, 2 vols., 1881.

[151]

The Earlier and Later Work of Titian. Portfolio, October 1897 and July 1898.

[152]

Tizian. Berlin, 1901.

[153]

La Vie et l'Oeuvre de Titien: Paris, 1886.

[154]

See Crowe and Cavalcaselle: *Titian*, i. 85. The fact that Titian's name does not occur in these records is curious and suggestive.

[155]

Ed. *Sansoni*, p. 459. The translation is that of Blashfield and Hopkins. Bell, 1897.

[156]

Ibid. p. 425.

[157]

Ibid. p. 428.

[158]

The translation is that of Crowe and Cavalcaselle. *Titian*, ii. 391. The original is given by them at p. 538.

[159]

Quoted from Crowe and Cavalcaselle.

[160]

Crowe and Cavalcaselle. *Titian*, ii. 409.

[161]

There is a collection of these in a volume in the British Museum.

[162]

Before the discovery of the letter to Philip, Messrs. Crowe and

Cavalcaselle were quite prepared to admit that Titian was born "after 1480" (vide *N. Italian Painting*, ii. 119, 120). Unfortunately, they took the evidence of the letter as final, but finding themselves chronologically in difficulties, they shrewdly remark in their *Titian*, i. 38, note: "The writers of these lines thought, and *still think*, Titian younger than either Giorgione or Palma. They were, however, inclined to transpose Titian's birthday to a later date than 1477, rather than put back those of Palma and Giorgione to an earlier period, and in this they made a mistake." Perhaps they were not so far wrong after all!

[163]

For this most amusing letter see Crowe and Cavalcaselle. *Titian*, i. p 153.

[164]

The evidence afforded by Titian's own portraits of himself (at Berlin and in the Uffizi) is inconclusive, as we do not know the exact years they were painted. The portrait at Madrid, painted 1562, might represent a man of seventy-three or eighty-six, it is hard to say which. But there is a woodcut of 1550 (*vide* Gronau, p. 164) which surely shows Titian at the age of sixty-one rather than seventy-four; and, finally, Paul Veronese's great "Marriage at Cana" (in the Louvre), which was painted between June 1562 and September 1563, distinctly points to Titian being then a man of seventy-four and not eighty-seven. He is represented, as is well known, seated in the group of musicians in the centre, and playing the contrabasso.

[165]

Jahrbuch der Sammlungen des A.H. Kaiserhauses, vii. p. 221 *ff* 1888.

[166]

Dr. Ludwig had the kindness to write to me on this subject: "Among the thousands of signatures of painters which I have seen I have never come across the signature *Maestro*. Of course, someone else can describe a painter as Master; he himself always subscribes himself *pittor, pictor*, or *depentor*."

[167]

Dr. Gronau further points out (in a letter recently sent to the writer) that Titian, writing to the emperor in 1545, says: "I should have liked to take them (i.e. the paintings) to your Majesty in person, but that my age and the length of the journey forbade such a course" (C. and C. ii. 103). Writing also

in 1548 to Granvella he refers to his "vechia vita." Would not such expressions (asks Dr. Gronau) be more applicable to a man of sixty-eight and seventy-one respectively than to one of only fifty-six and fifty-nine?

[168]

XXIV. Band. 6 Heft, p. 457.

[169]

January 1902, pp. 123-130.

[170]

Quoted from Crowe and Cavalcaselle. II. 344. The Spanish original is given at p. 535.

[171]

I have quoted Titian's letter in full in the *Nineteenth Century*. That of the Spanish Consul is given in the *Jahrbuch der Sammlungen des A.H. Kaiserhauses*, vii. p. 221, from which I extract the passage: "El dicho Ticiano besa pies y manos de V.M., y suplica umilmente a V.M. mande le sea pagado lo que le ha corrido de las pensiones de que V.M. le tiene echo merced en Milan y en esa corte, y la trata de Napoles, y con los 85 años de su edad servira a V.M. hasta la muerte."

[172]

I have quoted this letter also in full in the *Nineteenth Century*. I am indebted to M. Salomon Reinach for making this point (*Chronique des Arts*, Feb. 15, 1902, p. 53, where he expresses himself a convert to my views).

www.ingramcontent.com/pod-product-compliance
Lightning Source LLC
Chambersburg PA
CBHW070718210526

45170CB00021B/589